I AM 8-BIT

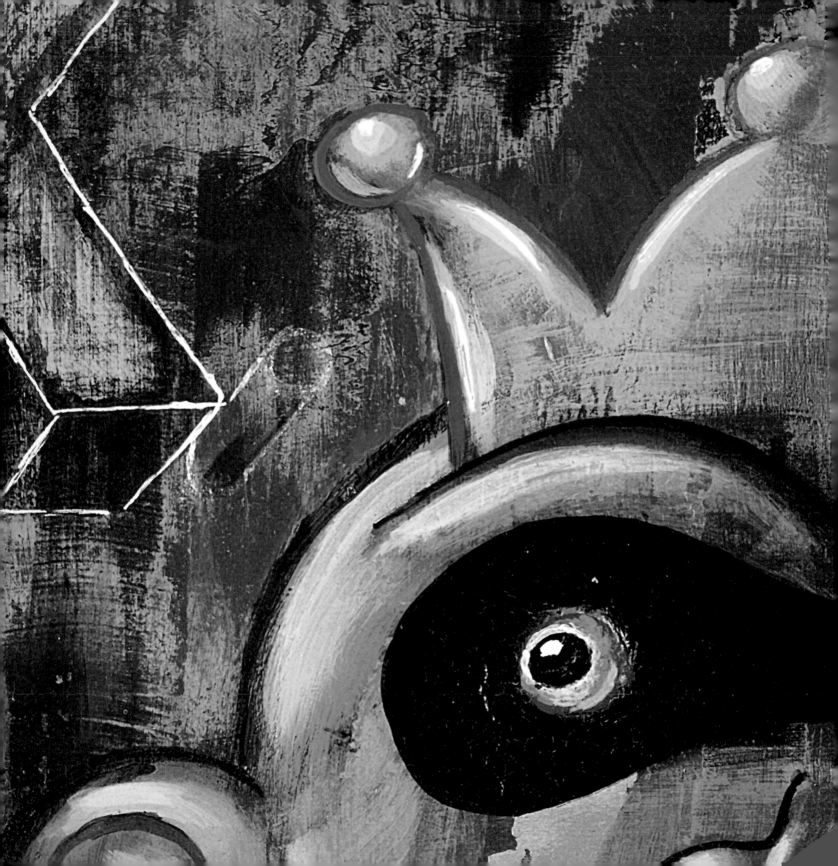

I AM 8-BIT

ART INSPIRED BY CLASSIC VIDEOGAMES OF THE '80S

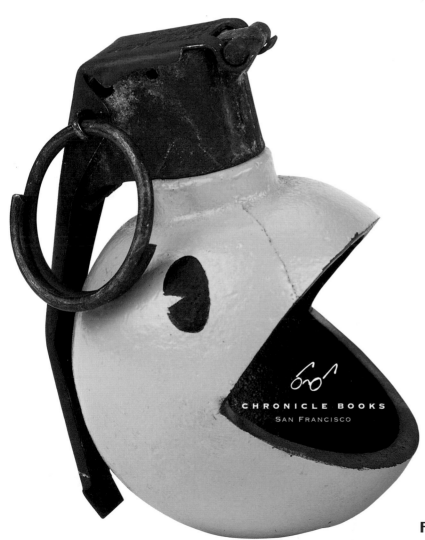

CHRONICLE BOOKS
SAN FRANCISCO

BY JON M. GIBSON
FOREWORD BY CHUCK KLOSTERMAN

Library of Congress Cataloging-in-Publication Data available.

ISBN 10: 0-8118-5319-5
ISBN 13: 978-0-8118-5319-4

Manufactured in Hong Kong.

Designed by **Altitude**

Photography by **Matthew Fried**

Distributed in Canada by Raincoast Books
9050 Shaughnessy Street
Vancouver, British Columbia V6P 6E5

10 9 8 7 6 5 4 3 2 1

Chronicle Books LLC
85 Second Street
San Francisco, California 94105
www.chroniclebooks.com

Page 2
Tony Mora
k.h., k.o.'d (detail)
acrylic on wood - 8 x 8 inches
Inspiration: *Mike Tyson's Punch-Out!!* (NES)

Page 3
Peter Gronquist
Untitled
grenades - 3 x 4 inches (detail)
Inspiration: *Pac-Man* (arcade)

Page 6
Anna Chambers
Lunch Time for Peach (detail)
stuffed, mixed media - 22½ x 18½ inches
Inspiration: *Super Mario Bros.* (NES)

Page 10
Gabe Swarr
Mario Block (detail)
acrylic on illustration board - 5 x 7 inches
Inspiration: *Super Mario Bros. 3* (NES)

Page 12
Tim Tomkinson
Duck Hunter S. Thompson (detail)
gouache, ink, and pencil on canvas - 8¼ x 7½ inches
Inspiration: *Duck Hunt* (NES)

Page 15
Greg "Craola" Simkins
Pac-Man in Hospice (detail)
acrylic on canvas - 24 x 18 inches
Inspiration: *Centipede, Dig Dug, Frogger, Joust, Super Mario Bros.* (all NES); *Pac-Man* (arcade)

TO THE PIXEL.

THIS, MY FRIEND,
IS FOR YOU.

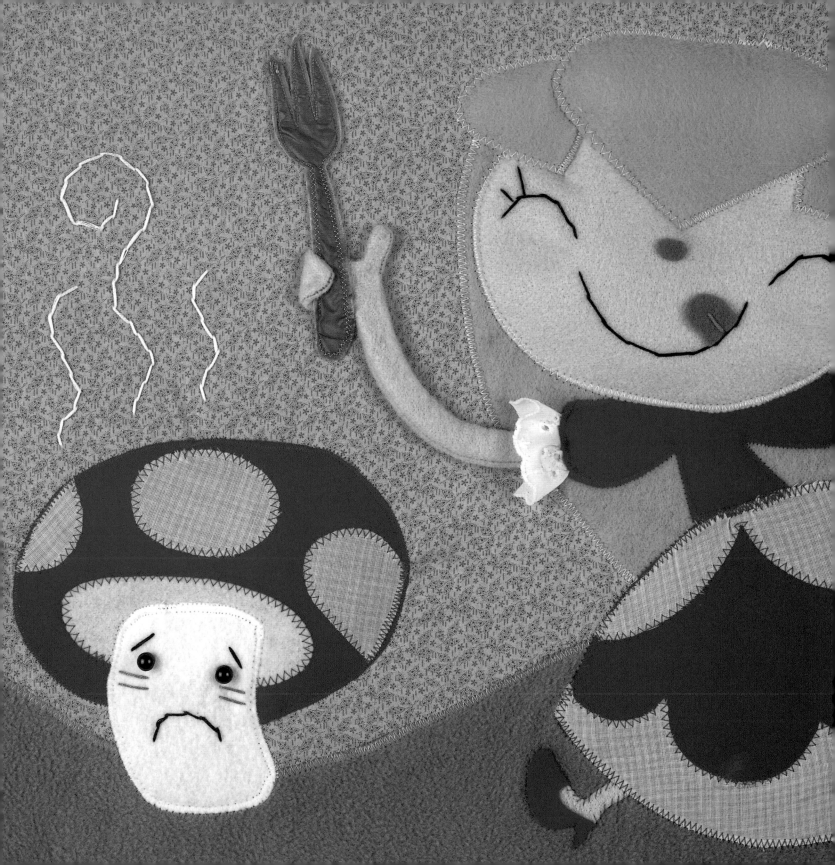

ACKNOWLEDGMENTS

KATIE CROMWELL, JENSEN KARP, AND FINNIGAN OF GALLERY 1988 (WWW.GALLERY1988.COM); JASON JONES, JONATHAN BRYANT, AND CHARLIE OF ACME GAME STORE (WWW. ACMEGAMESTORE.COM)—WITHOUT Y'ALL, **I AM 8-BIT** WOULD HAVE BEEN A MERE FIGMENT OF MY INSANE IMAGINATION. ALL THE ARTISTS, NO DOUBT—IT WAS YOUR INTENSE MEMORIES THAT FUELED THE IMAGES IN THIS BOOK. MATTHEW FRIED FOR ENDURING THE TASK OF PHOTOGRAPHING EVERYTHING... TWICE. MY MOM FOR SAYING, "DO WHAT YOU HAVE TO DO," THEN RELEASING ME INTO THE CALIFORNIA WILD. GABE SWARR FOR ALWAYS LISTENING, LAUGHING, AND DESIGNING AN AMAZING WEBSITE. TONY MORA FOR ALWAYS HELPING (WITH ANYTHING). JORGE R. GUTIERREZ FOR ALWAYS ARGUING AND ANALYZING. SANDRA EQUIHUA FOR ALWAYS SUPPORTING AND SINGING (SHE KILLS AT KARAOKE). JOSHUA STECKER FOR PIMPING THE CAUSE LIKE NO MAN HAS DONE BEFORE. SETH AND STACY OF 8-BIT WEAPON (WWW.8BITWEAPON.COM) FOR ROCKING THE HOUSE. KEITH ROBINSON AND THE REST OF THE INTELLIVISION AND CLASSIC GAMING MUSEUM CREWS FOR GETTING BEHIND THE IDEA. THESE FINE FOLKS WHO HELPED DEFINE "THE LITTLE ART SHOW THAT COULD": TED ADAMS, SUE APFELBAUM, AMID AMIDI, KACPER ANTONIUS, JESSE ASHLOCK, CHRIS BAKER, BILLY BERGHAMMER, BEN BERKOWITZ, TOBIAS BJARNEBY, DAVE BONDI, BRANDON BOYER, CRISPIN BOYER, CHRIS CARLE, TOM CONLON, BRIAN CRECENTE, DAYNA CROZIER, JANNAH DACANAY, ANISSA DORSEY, MOISE EMQUIES, SCOTT FLORA, JEFF GARCIA, GERARDO, MARK GREEN, TOM HAM, DAVE HALVERSON, SHAWN AND ANDREW HOSNER, VIVIAN HOST, NEIL HOYNES, DAN HSU, MATS JOHANSSON, GEOFF JOHNS, LOU KESTEN, SETH KLEINBERG, TINA KOWALEWSKI, JOEL KUWAHARA, DONNIE KWAK, CORY LEWIS, JASON MAGGIO, GUS MASTRAPA, GERARDO MEJIA, JOHN MIHALY, MELISSA MITCHELL, CHRIS NG, RAYMOND PADILLA, ALYSIA GRAY PAINTER, SERGIO PENNACCHINI, KEVIN PEREIRA, LEWIS PETERSON, BRIANNA POPE, GAVIN PURCELL, MICHAEL QUIROZ, DJ RAWN, ANDY REINER, MELISSA ROBINSON, TOM RUSSO, EVAN SHAMOON, ROB SIMAS, DEAN SCOTT, AMANDA SHIPMAN, JOHN SOLOMON, NATHAN SPOOR, KEVIN STEELE, PATRICIA STEELE, JJ STRATFORD, TOM STRATTON, TIM STREET, JONATHAN TAYSS, DREW TAYLOR, DREW THOMPSON, DAVE TOBIN, MICHAEL TRAN, TROY UNDERWOOD, ART VANDELAY, FRANCISCO VILLASENOR, JOHN WALSH, ROBERT WELKNER, ANDREW WILSON, ASHLEY WOOD, AND CLAYTON AND KITTY YORK. THOSE CHILDHOOD (AND ADULTHOOD) IDOLS WHO TAUGHT ME TO APPRECIATE ART... IN ALL ITS FORMS: BATMAN, LUC BESSON, KYLE COOPER, RICHARD CORLISS, NEIL GHIMN, JIM HENSON, YUKITO KISHIRO, JOHN KRICFALUSI, DAVE LEGG, GARY OLDMAN, JOHN MCNAMARA, WILL MILLER, SHIGERU MIYAMOTO, SYSTEM, QUENTIN TARANTINO, BILL MCCORD, DAVE MCKEAN, MCROBB, BRETT MEYER, FRANK NINTENDO ENTERTAINMENT BRUCE TIMM, CHRIS VISCARDI, CHRISTOPHER WALKEN, AND AN AMAZING DESIGN? BRIAN AT MAKING STELLAR ART LOOK WORKED THE PRODUCTION LIKE WEIRD AL YANKOVIC. PLUS, SINGER (NOT THAT ONE) AND THAT MUCH MORE AMAZING, NO OTHER. OH, AND THEN WHAT'S A BOOK WITHOUT BROOKE JOHNSON KICKED ASS AND YOLANDA ACCINELLI THERE'S THIS EDITOR GUY, KEVIN TOYAMA, WHO WELCOMED OF PUBLISHING AT CHRONICLE BOOKS I READ BUT ONLY DIDN'T FORGET YOU. YES, **YOU—** ME INTO THE HIGHER ECHELON BOOKS—A COMPANY WHOSE DREAMED OF MAKING. AND NO, I SO THANKS. YOU'RE AWESOME!

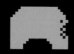

FOREWORD

Within the reality of videogames, time is elastic. Five minutes of **Madden Football** is like forty minutes of the NFC play-offs; thirty hours on **Grand Theft Auto** is like three years of crime; a week of **Civilization** can be twenty-five billion years of evolution. This being the case, the year 1993 (at least when you're talking about videogames) is long, long ago. Right now, it's entirely possible (in fact, entirely probable) that the best gamer on earth **was not even alive** in 1993. Within the context of this idiom, 1993 might as well be the Bronze Age.

But sometimes you need to talk about the Bronze Age, too.

In 1993, Dr. Timothy Leary was interviewed by Douglas Rushkoff, a journalist who would later write a book called **Media Virus**. They talked about **Pong.** What Leary said (and what Rushkoff proceeded to explain) was that **Pong** allowed modern kids to do something their parents never fathomed: they could control and manipulate what they saw on television. This was the most revolutionary media event since the invention of television itself. And what remains profoundly striking is how that sentiment was simultaneously (1) so obvious and (2) so overlooked by just about everyone.

Since '93, this idea of videogames being an active experience (unlike the passivity of TV, film, and audio recordings) has become a widely accepted notion. At this point, only a Maoist would discount the intellectual sophistication of gaming. Yet **i am 8-bit** is not a book about how videogames made smart people smarter; it is a book about how videogames changed the way creative people imagined a world that they were

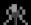

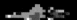

actively inventing. What you are about to see are not images that will seem completely familiar; what you are about to see are images that will seem **vaguely** familiar yet remain weirdly personal. They are, I suppose, the images of what artists saw when everyone else just saw pixels.

If you've ever really been absorbed into a particular video-game, you already understand how alive the game felt, and how alive it still seems in your mind. The games I loved most (**Ten-Yard Fight**, the original **Metal Gear** on NES, **M.U.L.E.**, and the first **Legend of Zelda**) don't seem like books I've

read or movies I've watched or songs I've heard; those other experiences were autonomous ideas I had to interpret. With videogames, I was the experience (or at least half of it). I made the choices, and I dictated the action. If the little flat-topped person from **Elevator Action** had a personality, his personality was mine. And this is what happens to anyone who ever twisted a joystick or thumbed a controller and imme-diately thought, "I like this." What they like is the process of making something nonexistent become who they are.

What you will see on the pages of this book is the manifes-tation of those transformations, projected on paper. In one sense, they are adaptations of cultural artifacts. But they're mostly just self-portraits.

—Chuck Klosterman

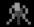

INTRODUCTION

FOR ME, IT WAS MARIO. A PUDGY PLUMBER WITH A FINE-COMBED 'STACHE MIGHT SEEM AN ODD ADDICTION FOR A WEE LAD OF FIVE, BUT WE DON'T PICK OUR FIXATIONS...

THEY CHOOSE US.

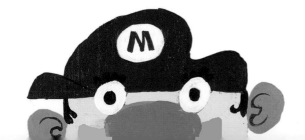

Grandma has her collection of crocheted cows, Stimpy has his mighty undertable of nose goblins, and I have my **ohh**-so-fond memories of a man and his many, many mushrooms.

Super Mario Bros. had it all—a megastar in the making (and overalls); a kingdom populated by psychedelics (floating blocks, squatty munchkin minions); and a princess indefinitely in peril (offering a reward of cake for your valiant efforts). You didn't just play it—you lived it. Mario was me. I was Mario. And so was an entire generation, consumed by the Italian idol. . . or countless other '80s videogame icons whose existence was lived out one quarter—or continue—at a time.

Face it: if you flipped this far in, it's obvious that a thick fog of nostalgia clouds the better half of your brain. The '80s were an era of button mashing when 3-D was a fantasy on par with flying cars—when gaming was about style, expression, and, most of all, unyielding fun. It's an aroma that hasn't been smelled since PlayStation plagued us

with polygons—those bitty soundtracks, sly yet simple animations, the **blips**, the **bleeps**. Ahh, the **bleeps**.

At a certain point, it becomes imprinted. It's instinctual. Like baby chicks, we flock to that one game that is our mother. Our babysitter. Our best friend. Our lover. Games were **my** refuge from an alcoholic father, a distraction from chores. They were a release of younger-brother aggression, a reward for a hard day's work. They were sympathetic, congratulatory, and warm. Playing was compulsive—it was beyond habitual—because you could go twenty minutes or twenty years and still have the same revved reaction: "Just. . . one. . . more. . . game."

Still, Kool-Aid's cool had an expiration date, and no matter how much you say you loved it, feathered hair went limp when the calendar tore into '91. But the classics—the **Dig Dug**s, **Donkey Kong**s, and **Duck Hunt**s of our youth—will never shrivel in the cruel cancer that is pop culture. They were the basic elements of gaming—the originals, the ingenues.

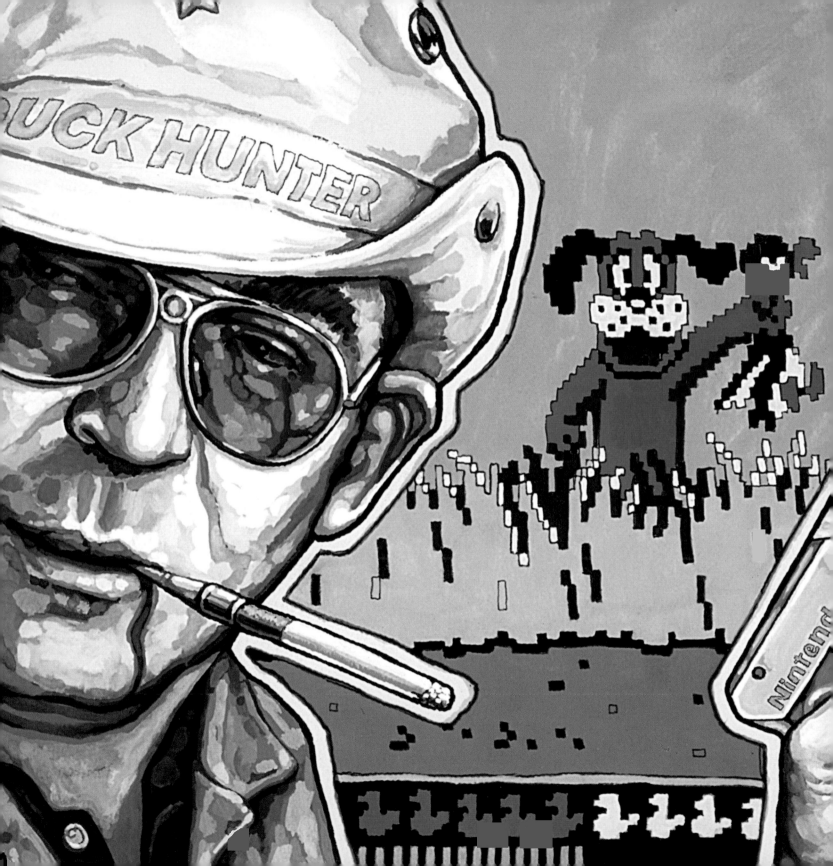

Forget earth, wind, fire, and water—we're talking **Asteroids**, **Zelda**, **Burger Time**, and **Tetris**. What we played then is the very foundation of what games are now, minus marketing gimmicks, schlocky mascots, and celebrity voice-overs. Games of the '80s weren't just rock 'n' roll—they were the pick that played the very first note. They were that inventive, that groundbreaking. They were that fucking **fresh**.

Every time a new game was released, it was like a Mack truck to the gut (in a good way). No matter how pixelscopic the improvements—a few more colors here, a zippier rhythm there—it was always so eye-fryingly new. Sure, compared to the pore-perfect technology we have today—capable of rendering hair follicles that you'll never actually see—graphics from the past were pretty primitive. Prehistoric, even. But it was those very limitations that drove designers to create, to innovate—to push every line of code and every measly microchip to the max. It was those intrepid few who gave us **Missile Command**'s earth-shattering trackball, **Street**

Fighter's mind-boggling combos, **Ms. Pac-Man**'s tear-jerking love story. These were the "WOW!" moments—when **oohs** and **ahhs** devolved into "No fucking way!" and overall shifts in blood pressure.

Month after month—game upon game—that was the stuff of legend, prompting scenes of recess gossip, school-skipping arcade stints, and late nights that would blur into early afternoons. History was being burned onto our retinas, and we were more than willing to show off the scars.

But it wasn't just personal lust; this was mass masturbation—kids huddled behind that lucky bastard of a joystick jockey, all drooling and swooning, cheering and jeering. For as far as that one life would take you, you were the king, the pope, the warrior, the rock star—you were directing the ultimate action movie for all to behold. You were sweating. Panting. Aching. Every twitch was noted, every technique logged. Your toggles were regarded with envious eyes. When you stepped down from your throne,

high score in tow, every single body in that room was your rival. That number was your momentary medal of honor. And your opponent, after a nod of approval, would stop at nothing to nudge you out of that record-breaking slot so he or she could carve his or her initials onto the screen. Punk.

From the instant you gripped that pad or tweaked that stick, that was it—hook, line, and 1-UP. For those of us lucky enough to be raised totally '80s, the game will never be over.

That's what **i am 8-bit** is all about. When I first walked into Gallery 1988 in Hollywood and proposed an art show that celebrated such a wicked addiction to the old school—the retro chic of that bygone era—there was no convincing, no doubt. Gallery owners Jensen Karp and Katie Cromwell simply got it. And so did our dream army of artists, a core of extraordinarily talented animators, painters, cartoonists, designers, sculptors, sewers, and illustrators who, too, once breathed that pixelated air. And so did 1,500-some attendees at the opening night who came to admire everything from

Greg "Craola" Simkin's geriatric Pac-Man feeding off an IV of pellets to Sean Clarity's pixel-dimensional rendering of **Excitebike**. Again, years later, it was a room jammed with players, grown-up yet still wide-eyed—the same community of nerds who would beg, plead, and just about kill for a one-buck bump in allowance to stake claim to that brand-spankin' new NES cartridge.

It was the reunion of complete strangers with a common love. It was the next level.

Still, it hadn't truly sunk in until the party had calmed, the gamers had gone, and only the art remained. No matter how you bake it, shake it, or bust it up—for better or worse—those classic games are a permanent part of us, a tattoo on the mind. Being 8-bit means being whole—being real. We are what we play.

We are 8-bit.

—Jon M. Gibson, curator, gamer

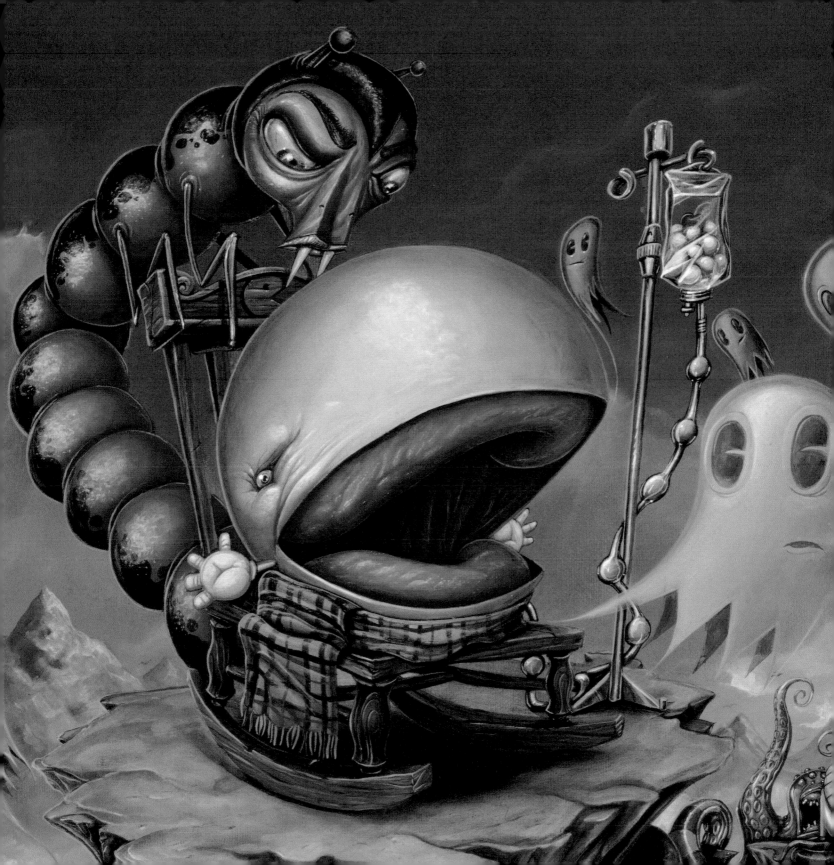

01600

Joe Ledbetter
Rampage
acrylic on wood - 21 x 25½ inches
Inspiration: *Rampage* (arcade)

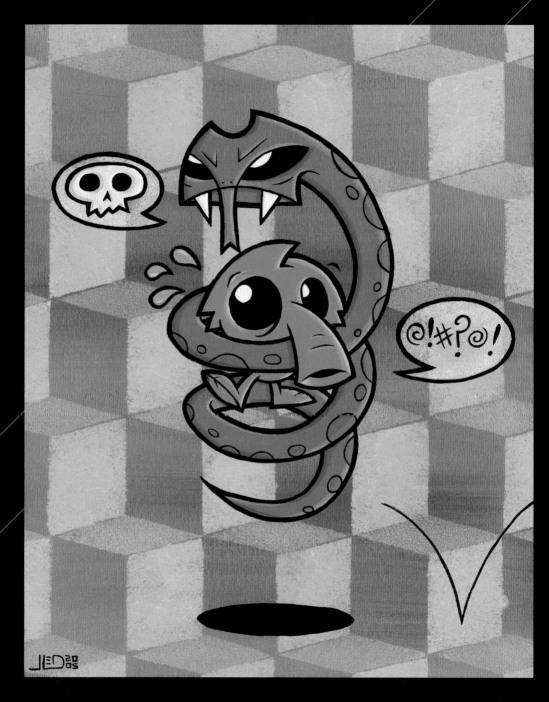

Joe Ledbetter
@!#?@!
acrylic on canvas - 11 x 14 inches
Inspiration: *Q*bert* (arcade)

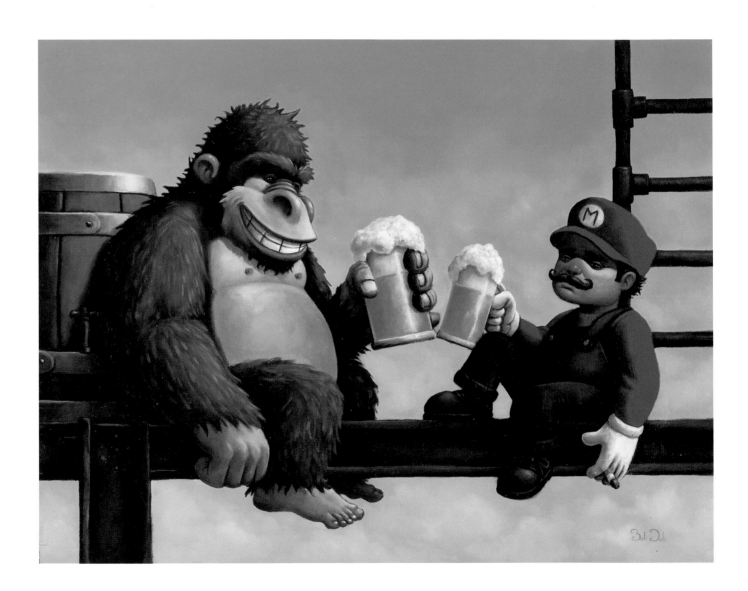

01800 **Bob Dob**
Cheers
oil on panel - 13 x 10 inches
Inspiration: *Donkey Kong* (arcade)

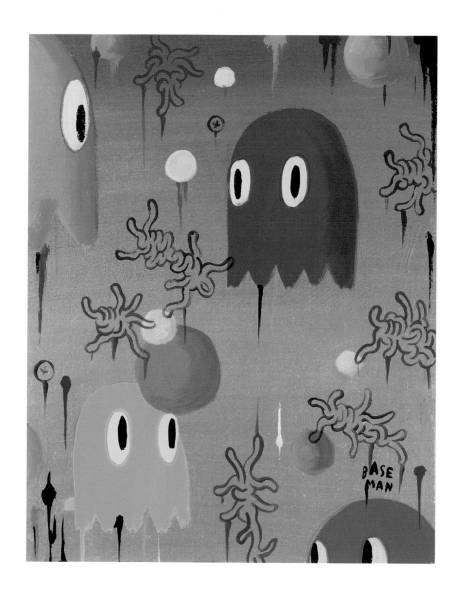

Gary Baseman
Pac-Man vs. Base-Man
acrylic on wood - 12 x 16 inches
Inspiration: *Pac-Man* (arcade)

02000 **Foi Jimenez Jurado**
Looking for the Secret Passage
graphite on paper - 10½ x 8 inches
Inspiration: *Super Mario Bros.* (NES)

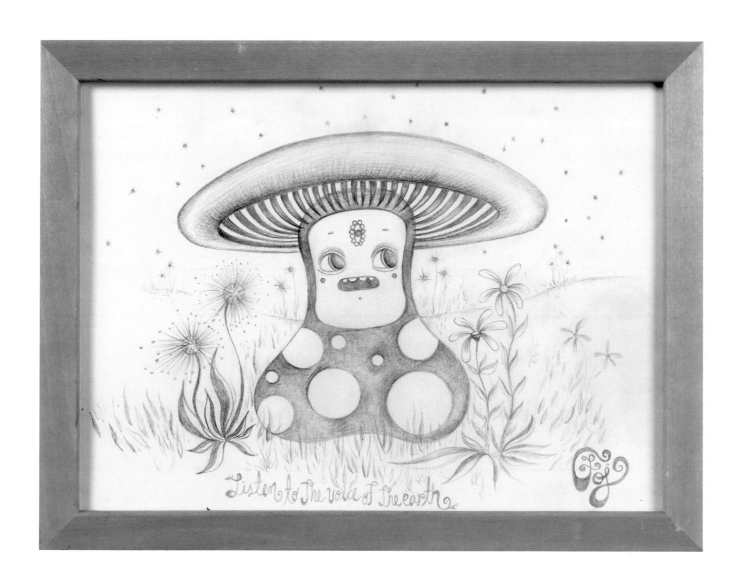

Foi Jimenez Jurado
Listen to the Voice of the Earth
graphite on paper - 10½ x 8 inches
Inspiration: *Super Mario Bros.* (NES)

02100

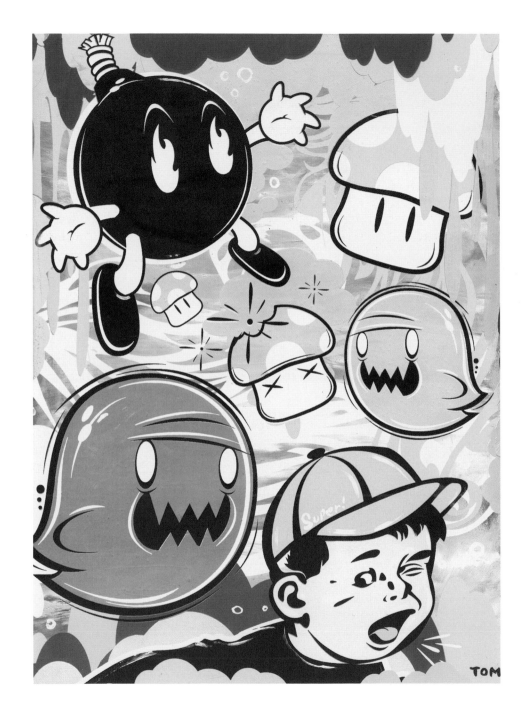

02200

Thomas Han
Super Mushroom Boogie
mixed media on wood - 9 x 12 inches
Inspiration: *Super Mario Bros.* (NES)

Super Mario Bros. had one of the most influential, contemporary characters out there. **SUCH A GREAT MIX OF CUTE AND CREEPY POSSESSED THOSE OBSCURE MONSTERS AND LANDSCAPES.**

—Thomas Han

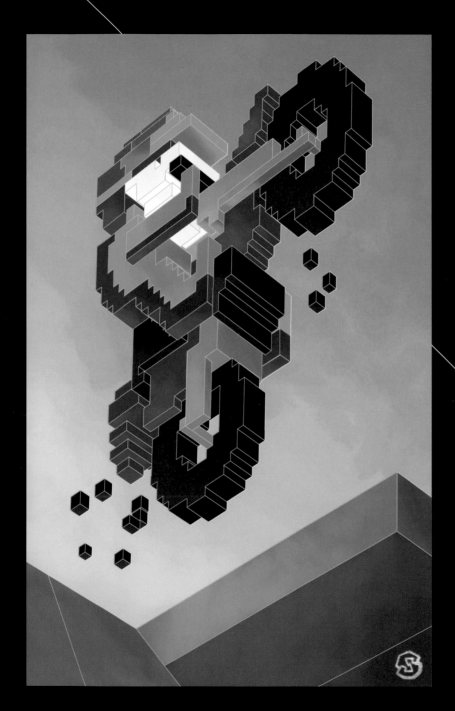

02400 **Sean Clarity**
Excitebike
mixed media on canvas - 11 x 17 inches
Inspiration: *Excitebike* (NES)

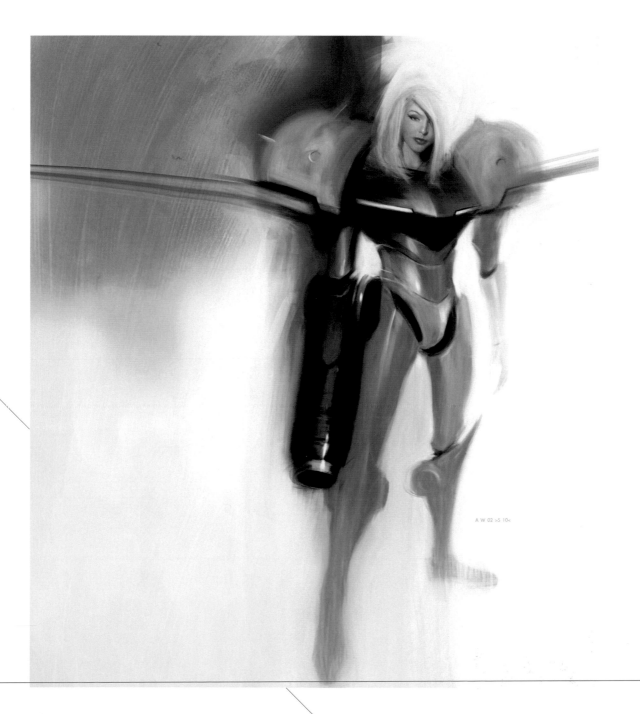

Ashley Wood
Untitled
mixed media - 8¾ x 10 inches
Inspiration: *Metroid* (NES)

02500

02600 **Erik Otto**
 All You Need Is a Bar
 pencil on found wood - 12 x 12 inches
 Inspiration: *Tetris* (NES)

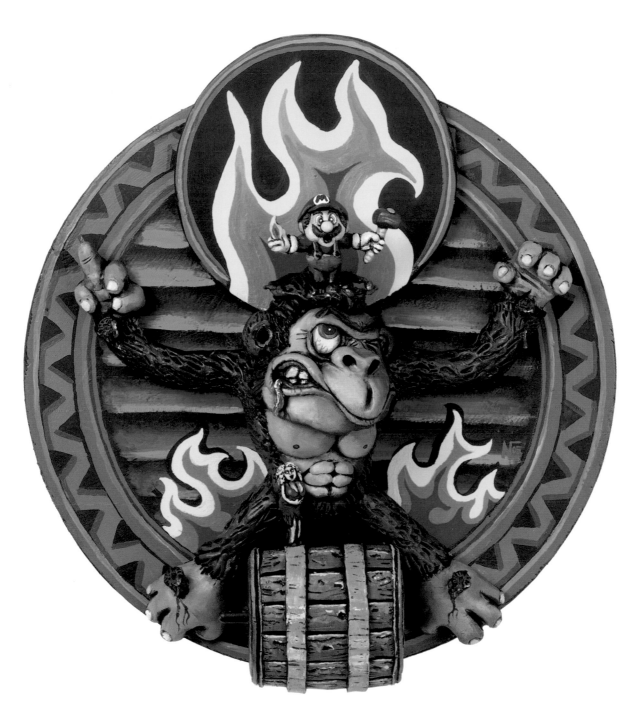

Nathan Cartwright
The Passion of the Kong
sculpted, mixed media - 13 x 14 inches
Inspiration: *Donkey Kong* (arcade)

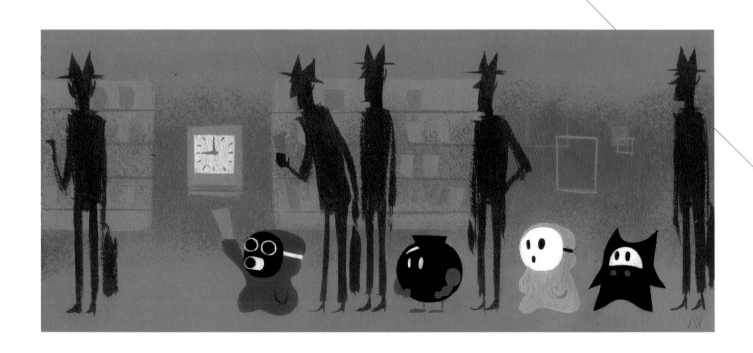

02800 **Amanda Visell**
 Clockin' In
 acrylic on board - 17 x 10½ inches
 Inspiration: *Super Mario Bros. 2* (NES)

Amanda Visell
Level 1016
acrylic on board - 12 x 14 inches
Inspiration: *Frogger* (arcade)

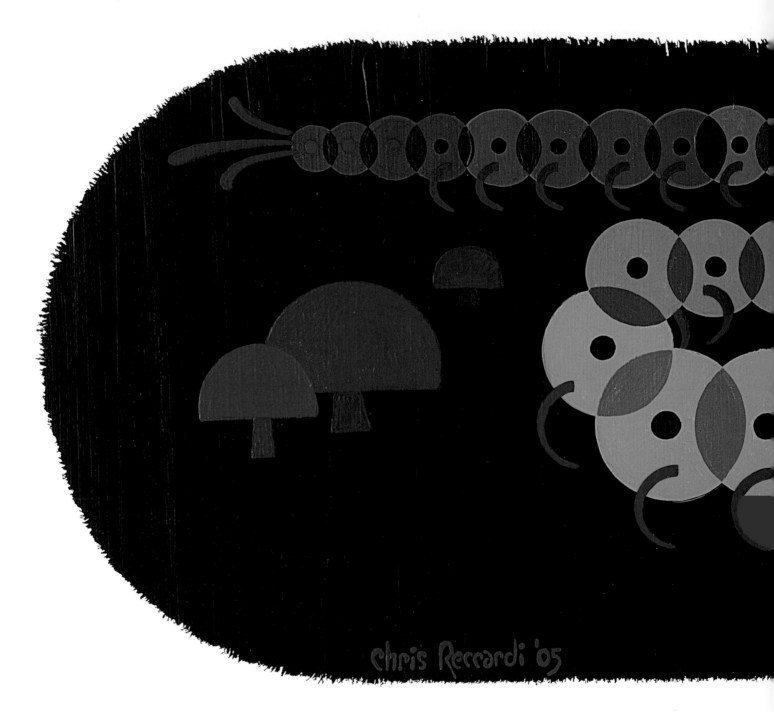

Chris Reccardi
Robopede 1
acrylic on board - 28 x 16 inches
Inspiration: *Centipede* (arcade)

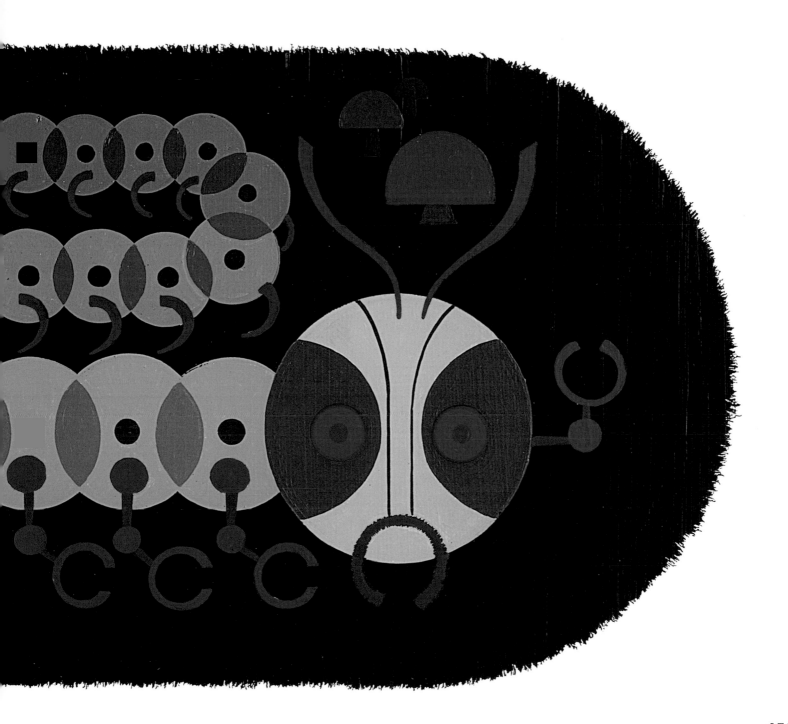

03100

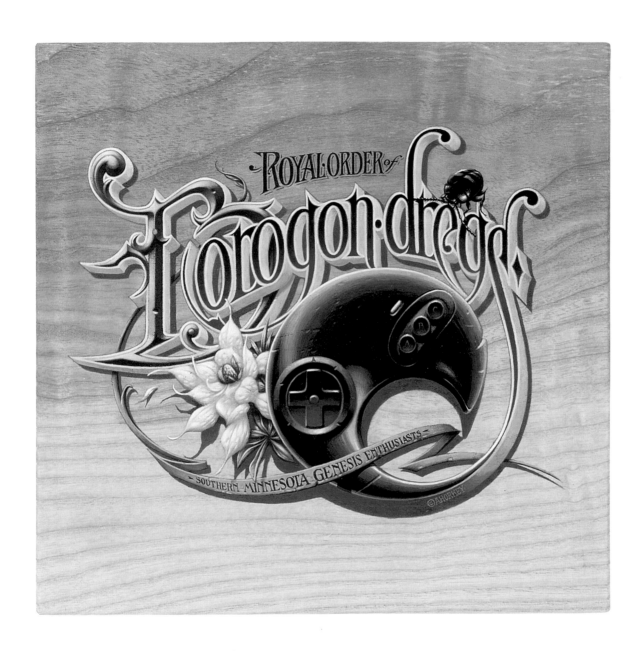

03200 **Aaron Horkey**
Borogon Dregs
acrylic on ash - 6 x 6 inches
Inspiration: Sega Genesis

YOU CAN'T BEAT THE AESTHETIC OF THE GENESIS—BLACK, SLEEK, AND AS METAL AS A VIDEOGAME SYSTEM IS GONNA GET. A lot of the early games were dark as well—graphically and thematically. **Ghouls 'N Ghosts, MUSHA, Sword of Vermillion, ESWAT, Truxton**, and so forth—there was nothing cute about those games. It was a great time to be a kid.

—Aaron Horkey

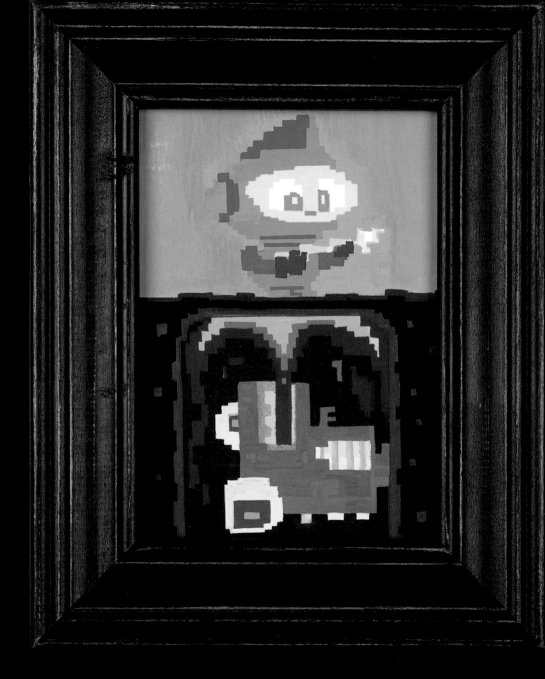

03400

Roman Laney
Fygar's Revenge
gouache on board - 8 x 10 inches
Inspiration: *Dig Dug* (arcade)

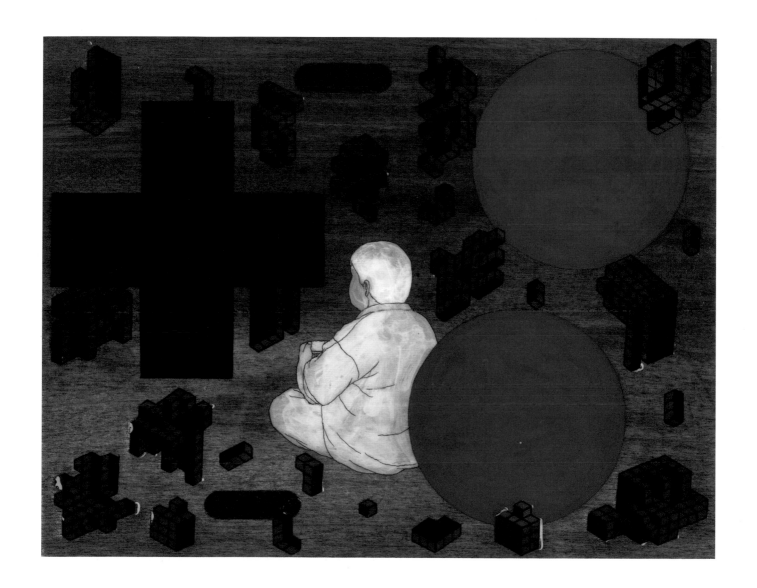

John Pham
Sedentary
mixed media on wood - 9½ x 7½ inches
Inspiration: *Tetris* (NES)

03500

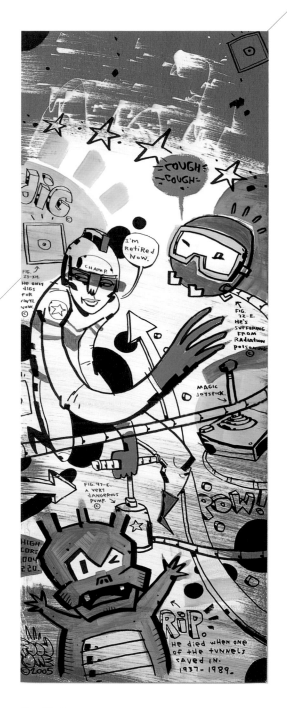

Jim Mahfood
Record Dug Digger
acrylic and marker on wood - 11 x 28 inches
Inspiration: *Dig Dug* (arcade)

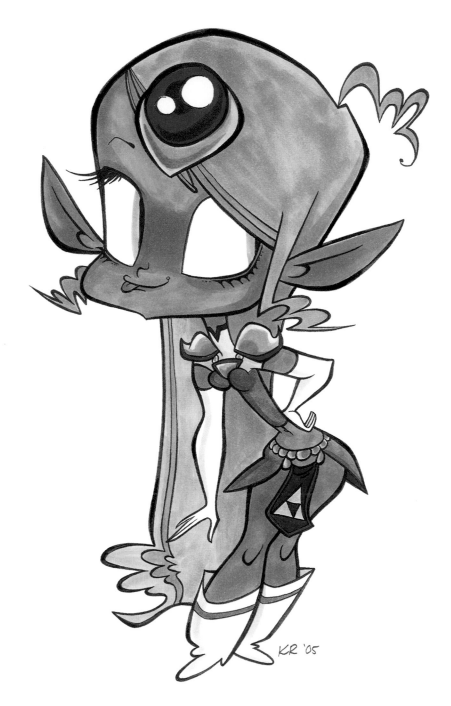

03800

Katie Rice
Princess Zelda (Girls of Nintendo series)
ink and marker on illustration paper - 8½ x 11 inches
Inspiration: *The Legend of Zelda* (NES)

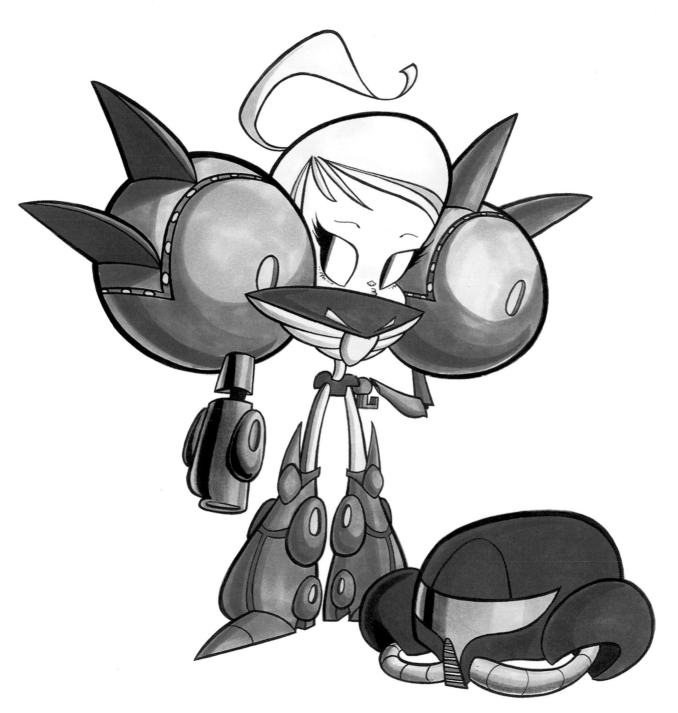

Katie Rice
Samus (Girls of Nintendo series)
ink and marker on illustration paper - 8½ x 11 inches
Inspiration: *Metroid* (NES)

03900

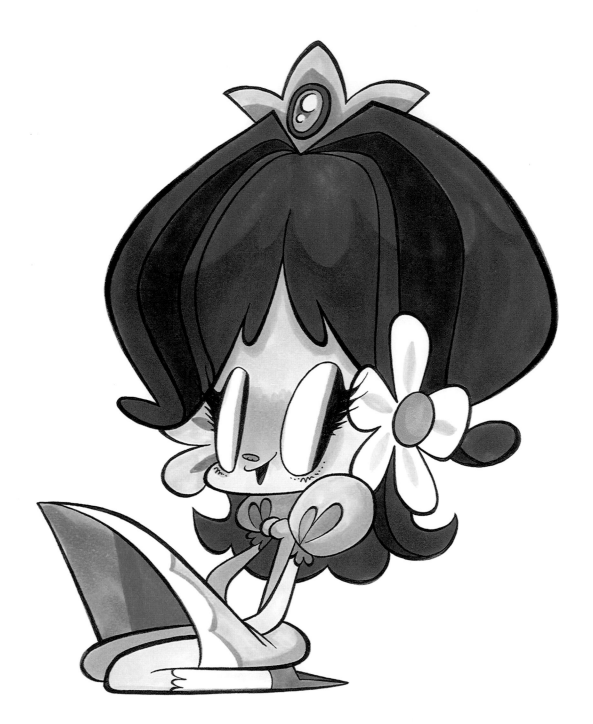

04000

Katie Rice
Daisy (Girls of Nintendo series)
ink and marker on illustration paper - 8½ x 11 inches
Inspiration: *Super Mario Land* (Game Boy)

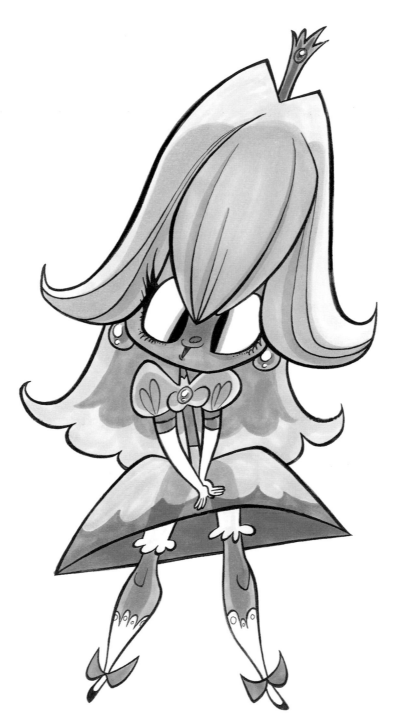

Katie Rice
Peach (Girls of Nintendo series)
ink and marker on illustration paper - 8½ x 11 inches
Inspiration: *Super Mario Bros.* (NES)

04100

THE NINTENDO WAS MY BABYSITTER. If I

wasn't skateboarding, I was playing the Nintendo 'til my fingers were raw from those damned square controllers. I also remember that the wall in my bedroom had all these little angular holes from when I would throw tantrums, cuss, and chuck my controller at the wall as hard as I could because I couldn't pass a part in the game—and yet, the controller never broke! They don't make controllers like they used to.

—Jose Emroca Flores

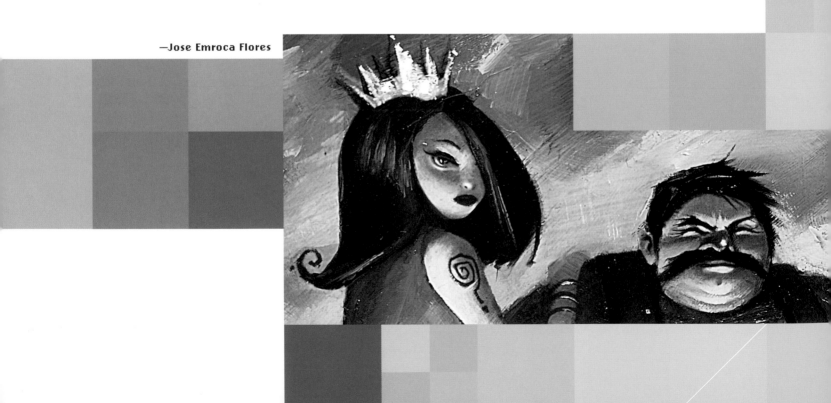

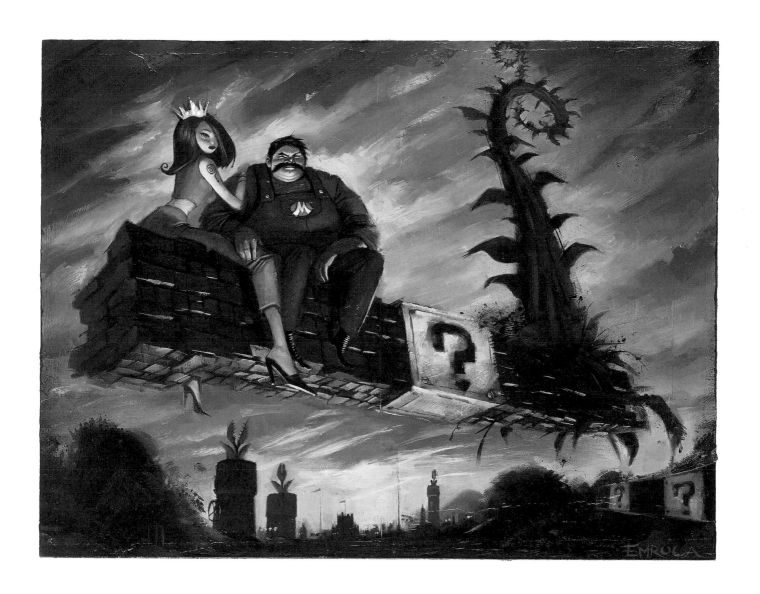

Jose Emroca Flores
The M.K.
oil on board - 22½ x 17 inches
Inspiration: *Super Mario Bros.* (NES)

04400

Emily Smith
Pac-Man Alley
photo - 18 x 22 inches
Inspiration: *Pac-Man* (arcade)

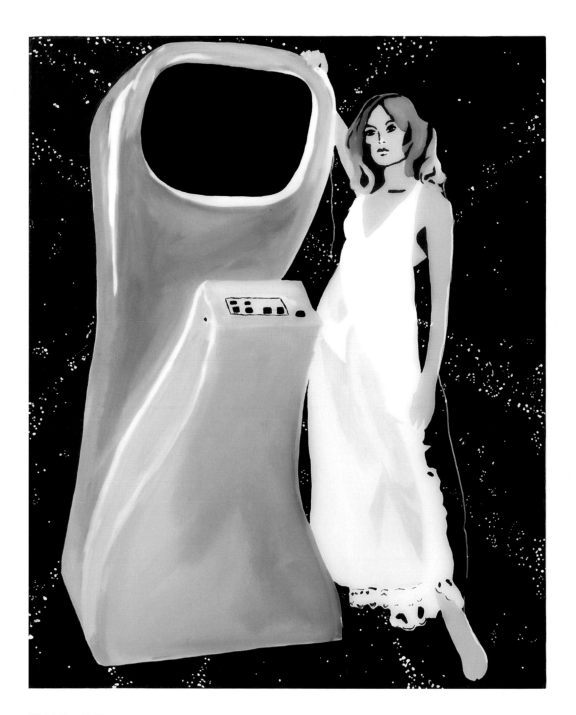

Nikki Van Pelt
Computer Space
acrylic and resin on canvas - 16 x 20 inches
Inspiration: *Computer Space* (arcade)

04500

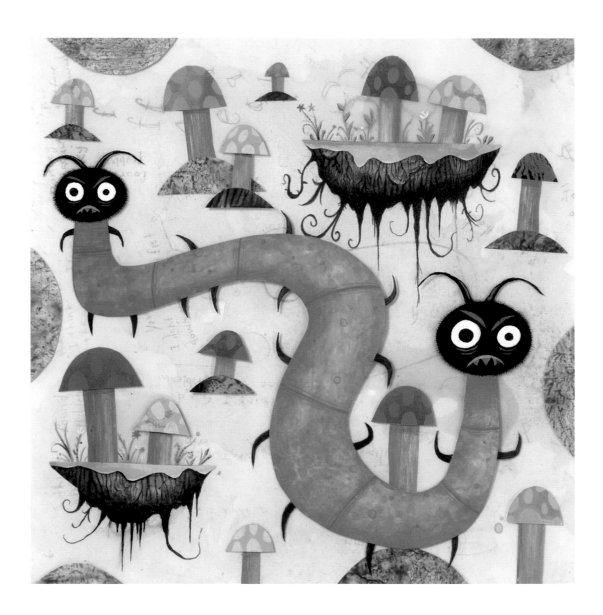

04600 **Michael Slack**
Centipede
mixed media on plastic and paper - 12½ x 12½ inches
Inspiration: *Centipede* (arcade)

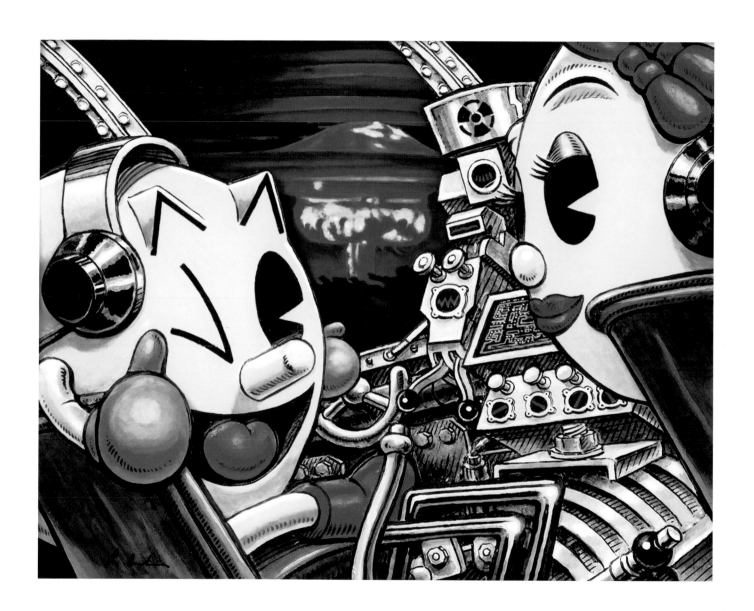

Dennis Larkins
Playing the Nuclear Option
sculpted, mixed media - 15 x 12 inches
Inspiration: *Ms. Pac-Man* (arcade), *Pac-Man* (arcade)

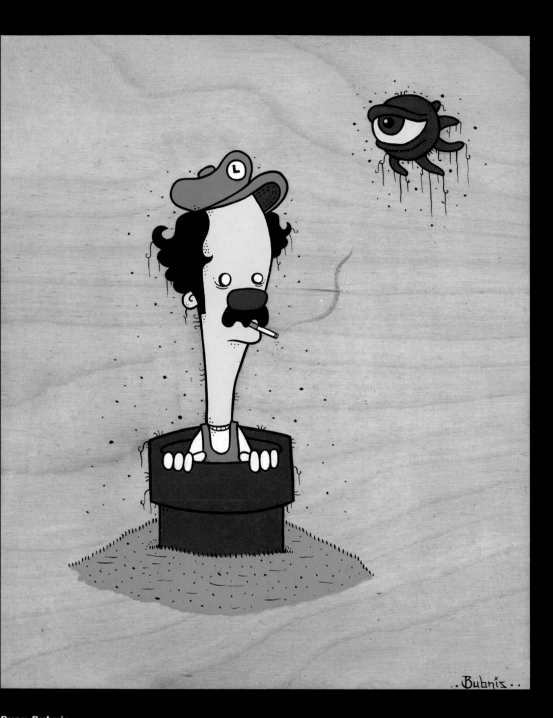

Ryan Bubnis
Lost, Luigi Encounters a Floating Monoeye
acrylic on wood - 8 x 10 inches
Inspiration: *Kid Icarus* (NES), *Super Mario Bros. 2* (NES)

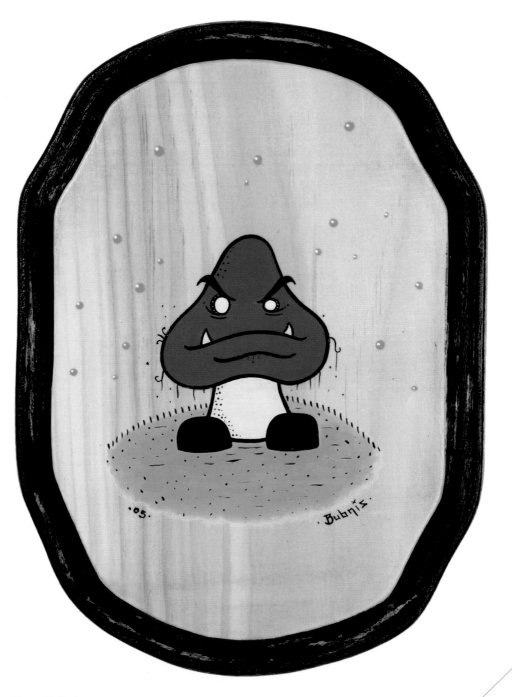

Ryan Bubnis
Goody Goody Goomba
acrylic on wood - 5 x 7 inches
Inspiration: *Super Mario Bros.* (NES)

04900

I was never skilled enough to beat Gannon and save Princess Zelda. I had both **Zelda**s on the NES and spent countless hours plopped in front of the TV trying to beat them, with no such luck. **SO I THOUGHT IT WOULD BE FUNNY AND INTERESTING TO REVISIT LINK YEARS AFTER HIS DEFEAT AND SEE HOW HE WAS COPING WITH THE LOSS.** You know, fatten him up a bit, throw on a beard, give him a cigarette, and so forth.

—Ryan Bubnis

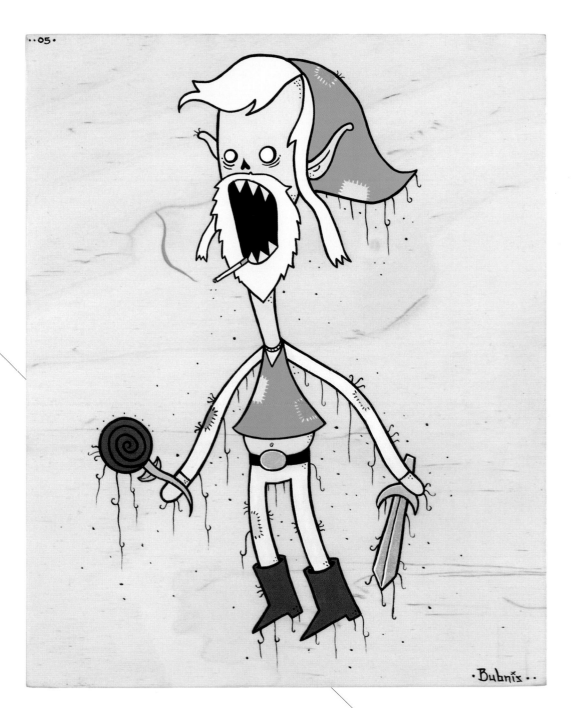

Ryan Bubnis
Mourning the Loss of the Princess
acrylic on wood - 8 x 10 inches
Inspiration: *The Legend of Zelda* (NES)

05100

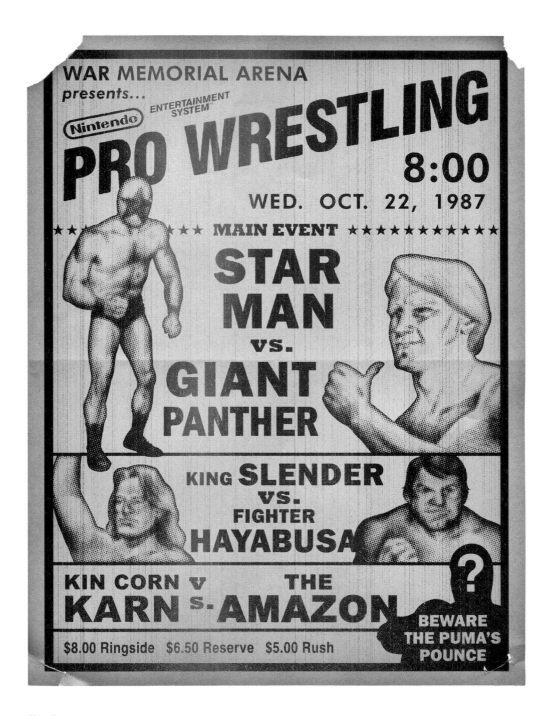

Jim Rugg
Starman vs. Giant Panther
mixed media - 9 x 12 inches
Inspiration: *Nintendo Pro-Wrestling* (NES)

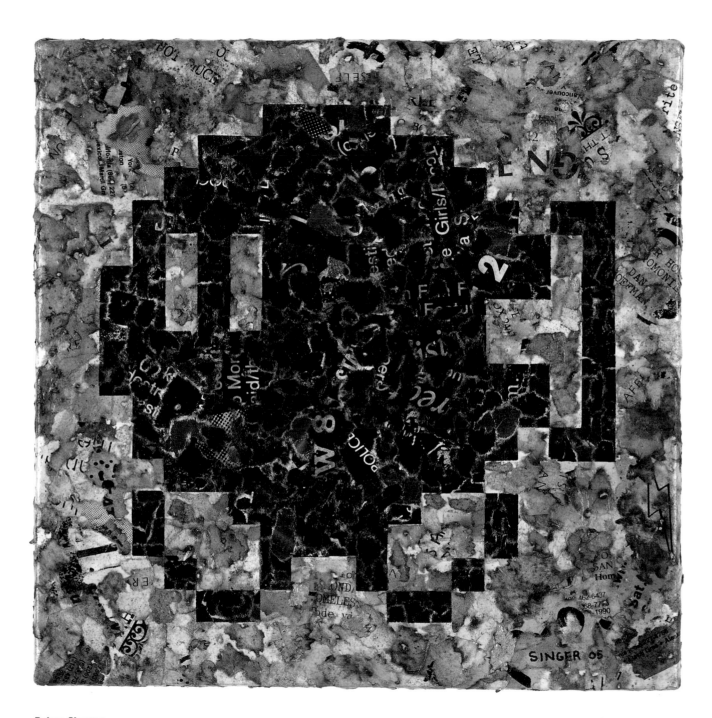

Brian Singer
Bobomb
mixed media - 8 x 8 inches
Inspiration: *Super Mario Bros.* (NES)

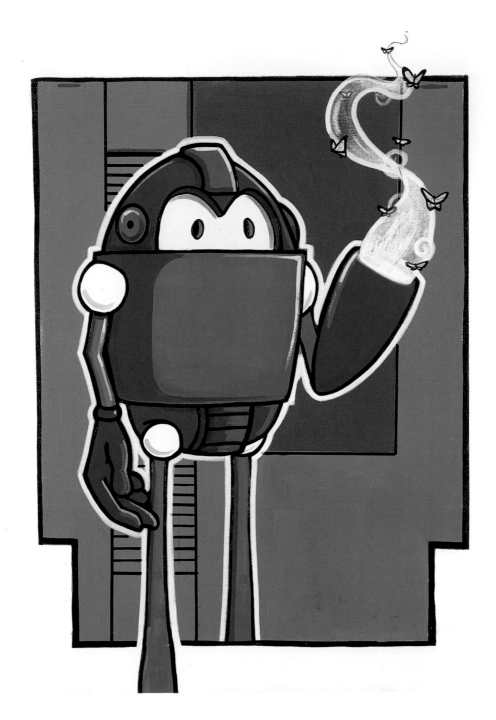

05400

Dan Fleres
Megabot
acrylic on canvas - 16 x 20 inches
Inspiration: *Mega Man* (NES)

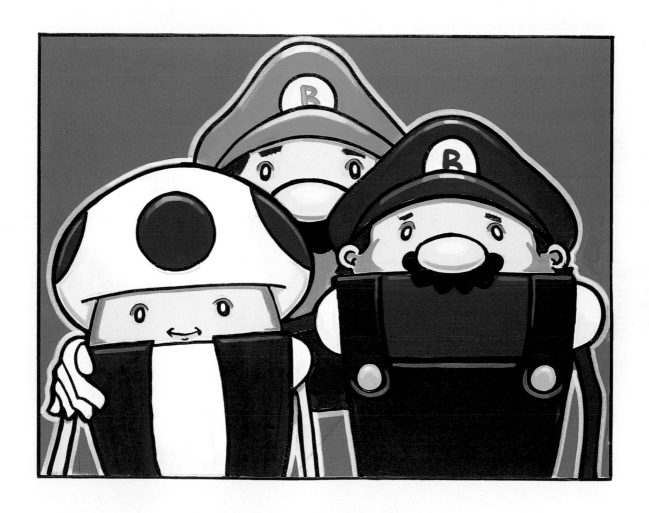

Dan Fleres
Super Mario Robots
acrylic on canvas - 20 x 16 inches
Inspiration: *Super Mario Bros.* (NES)

05500

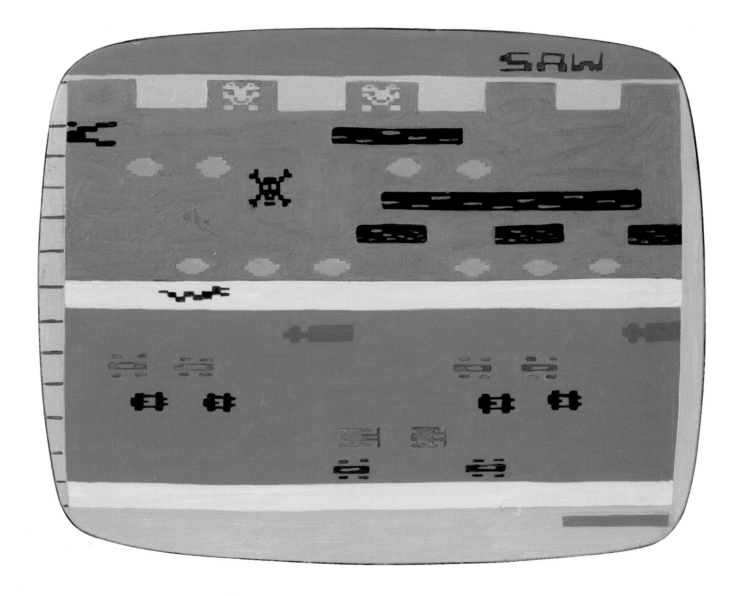

05600 **Scott Saw**
Game Over 1
oil on wood - 8 x 10 inches
Inspiration: *Frogger* (arcade)

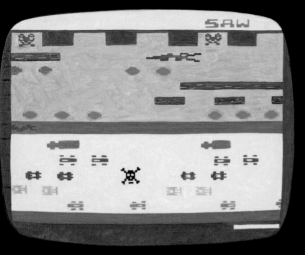

Scott Saw
Game Over 2
oil on wood - 8 x 10 inches
Inspiration: *Frogger* (arcade)

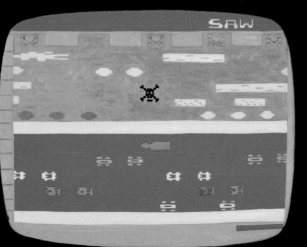

Scott Saw
Game Over 3
oil on wood - 8 x 10 inches
Inspiration: *Frogger* (arcade)

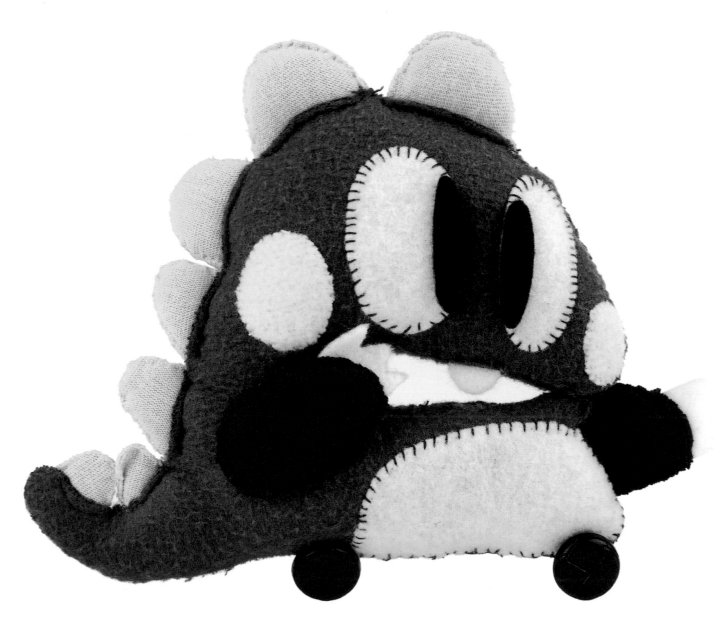

05800 **Love Ablan**
 Bobblun (a.k.a. Bob)
 mixed media, stuffed - 6½ x 5½ inches
 Inspiration: *Bubble Bobble* (NES)

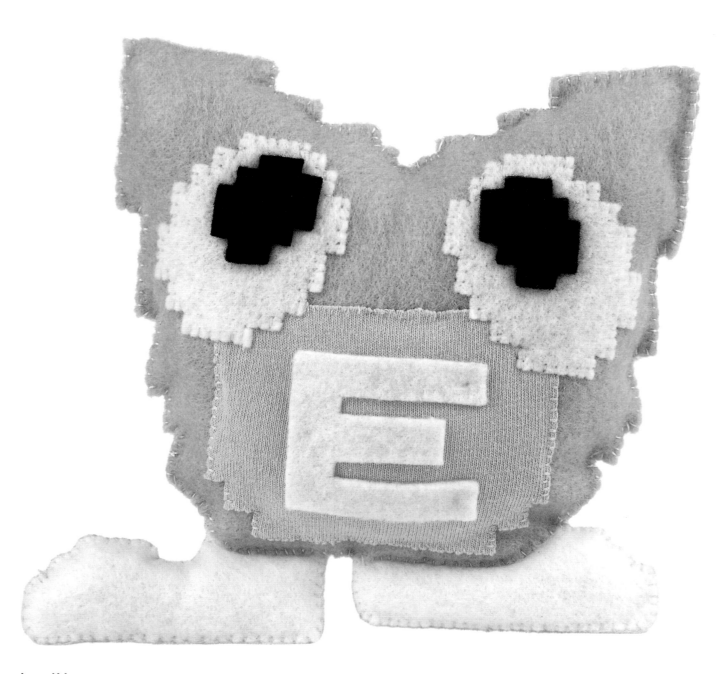

Love Ablan
E
mixed media, stuffed - 6 x 6 inches
Inspiration: *Mr. Do* (arcade)

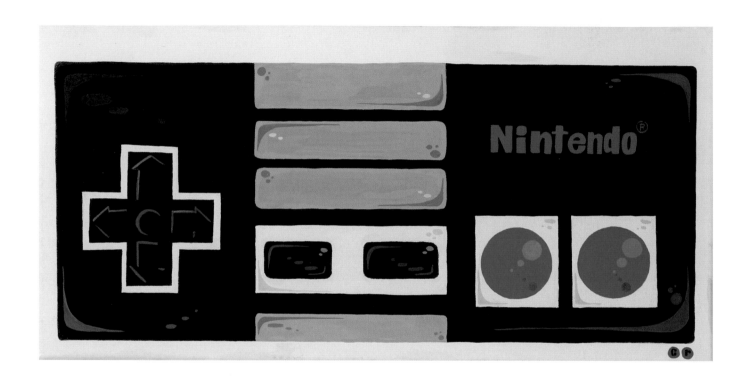

06000 **Carlos Ramos**
 Nintendo Controller
 cel paint on canvas - 24 x 12 inches
 Inspiration: Nintendo Entertainment System

I REMEMBER PLAYING NES UNTIL MY HANDS WERE TOO SORE TO CARRY ON.

Our favorite habit became playing in two-player mode; when you died, the other person would play, but you'd still work the other controller in the hopes of sharpening your skills.

—Carlos Ramos

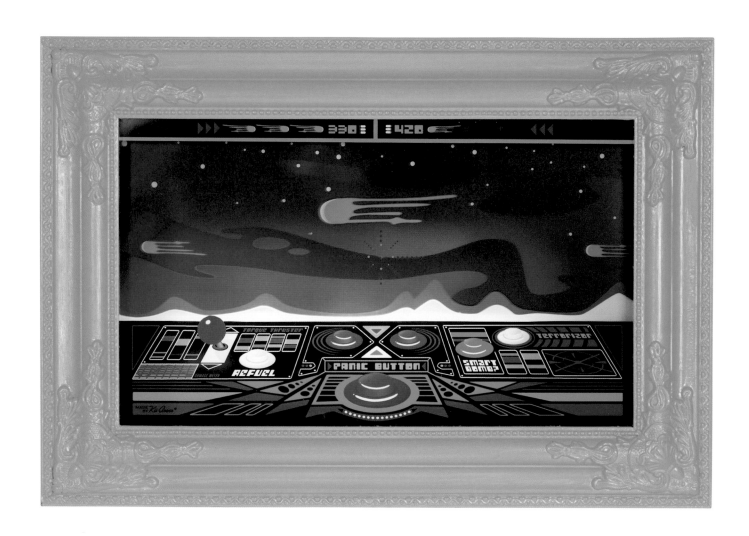

06200 **Kii Arens**
Smart Bomb
mixed media - 20 x 14¼ inches
Inspiration: *Defender* (arcade)

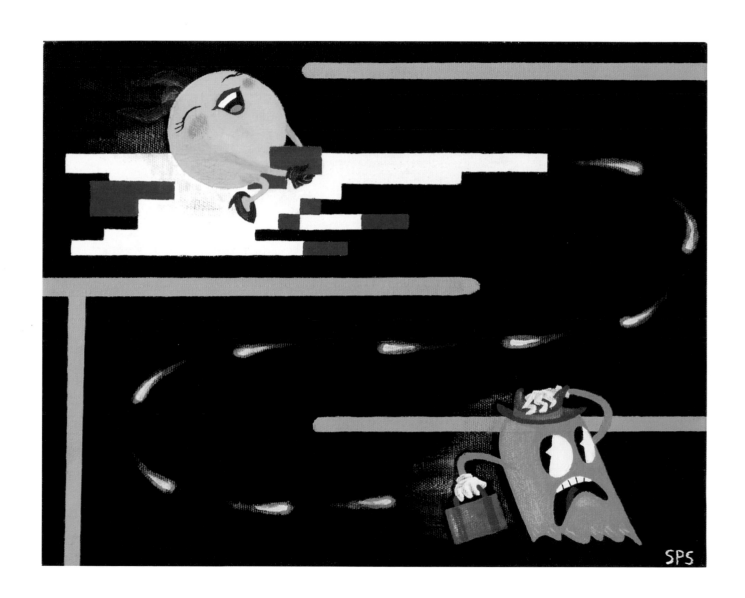

Sean Szeles
Ms. Pac-Man Takes a Joyride
acrylic on canvas - 14 x 11 inches
Inspiration: *Galaga* (arcade), *Ms. Pac-Man* (arcade)

06300

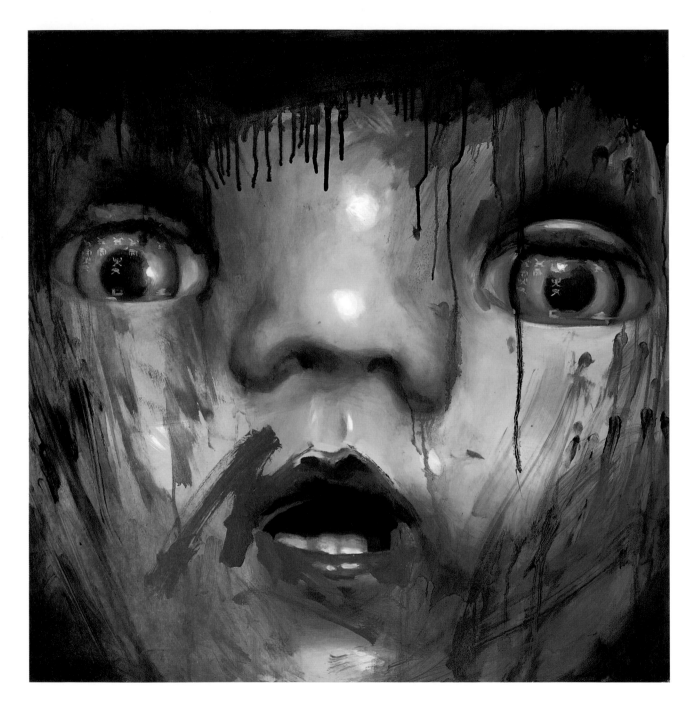

06400 **Shawn Barber**
Forerunner
oil on panel - 24 x 24 inches
Inspiration: *Space Invaders* (arcade)

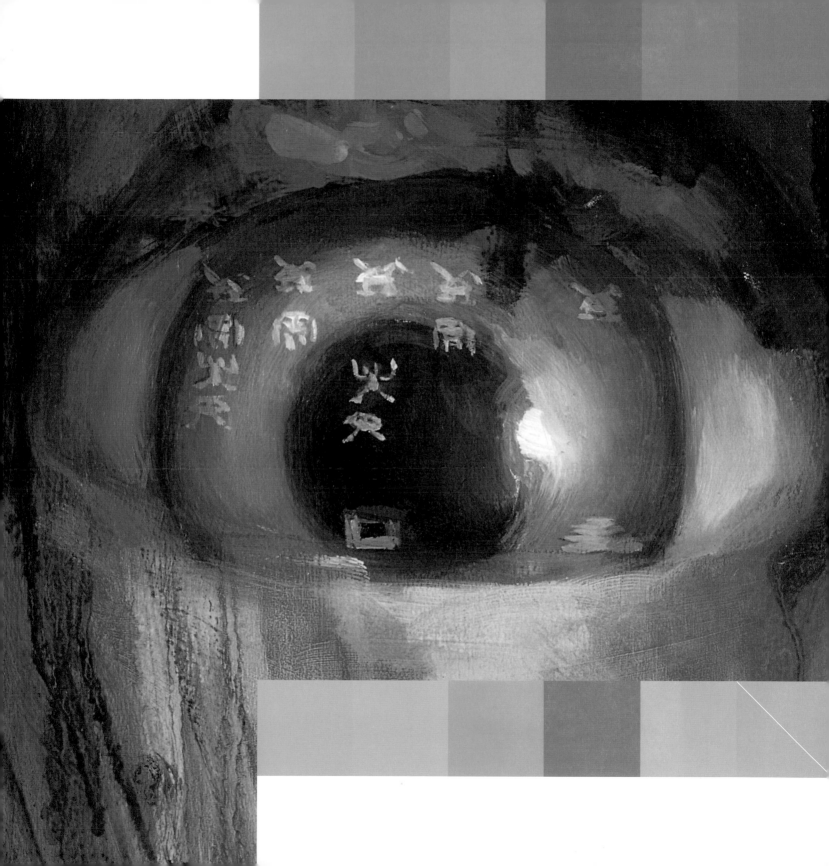

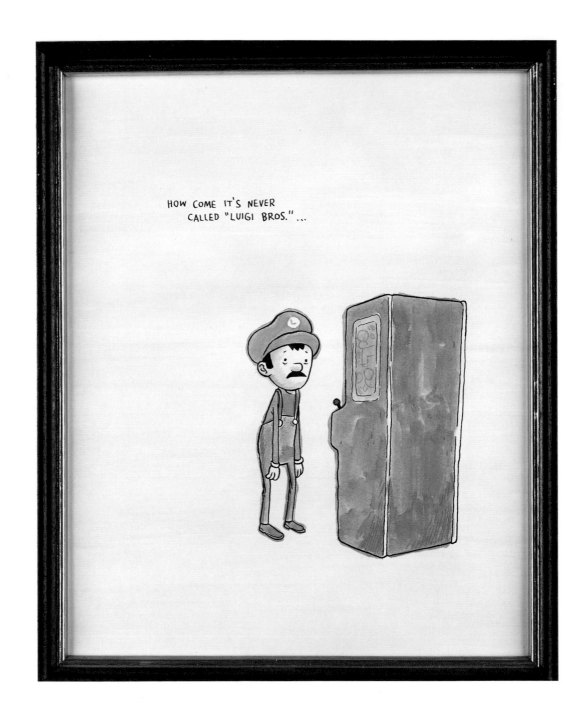

06600 **Martin Cendreda**
Luigi Bros.
ink and watercolor on paper - 9 x 10½ inches
Inspiration: *Mario Bros.* (arcade)

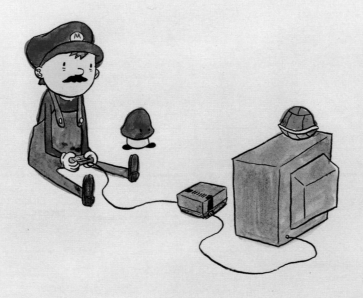

IT'S JUST NOT AS MUCH FUN WHEN IT'S YOUR DAY JOB

Martin Cendreda
Mario Plays NES
ink and watercolor on paper - 10½ x 9 inches
Inspiration: *Super Mario Bros.* (NES)

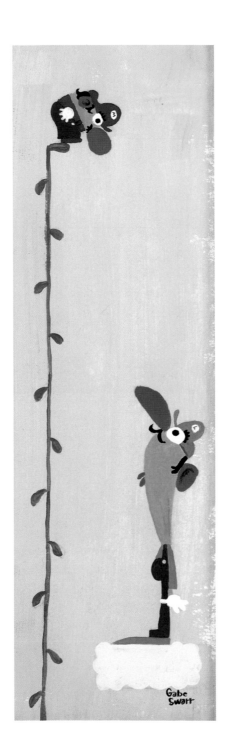

Gabe Swarr
Brother!
acrylic on illustration board - 5½ x 13½ inches
Inspiration: *Super Mario Bros. 2* (NES)

When I first played **Super Mario Bros.**, my brain could barely comprehend that it was my fingers forcing the little red-and-brown plumber to run and get hurt. Then it was my brother's turn to hurt the little green-and-white man. We loved it! Over and over again, we forced the tiny Italian men to do our bidding.

I'VE ALWAYS LOVED HAVING A SLAVE TO SQUASH THOSE PESKY MUSHROOMS, THROW FIREBALLS, OR JUST STOMP ON PEOPLES' HEADS TO MAKE THEM DIS-APPEAR. MARIO IS MY HERO.

—Gabe Swarr

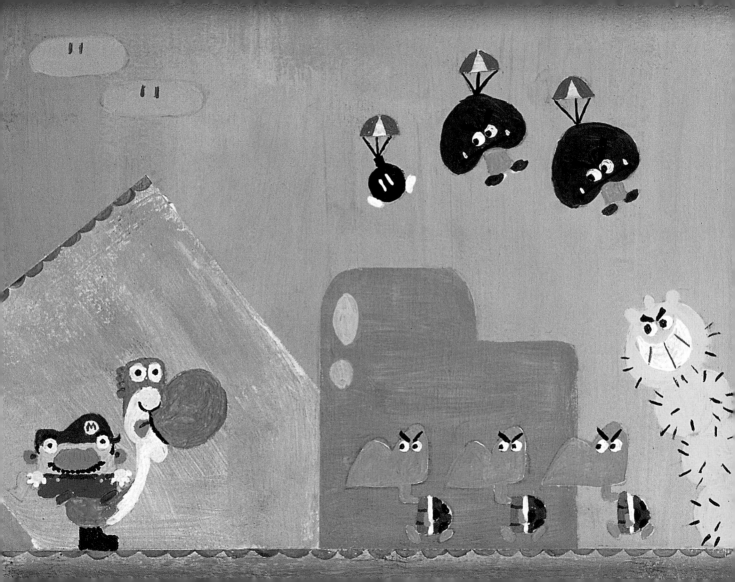

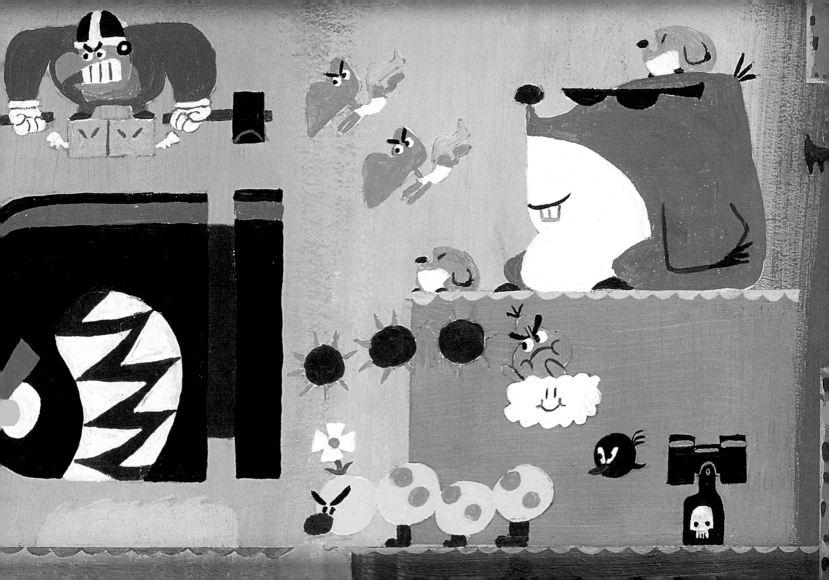

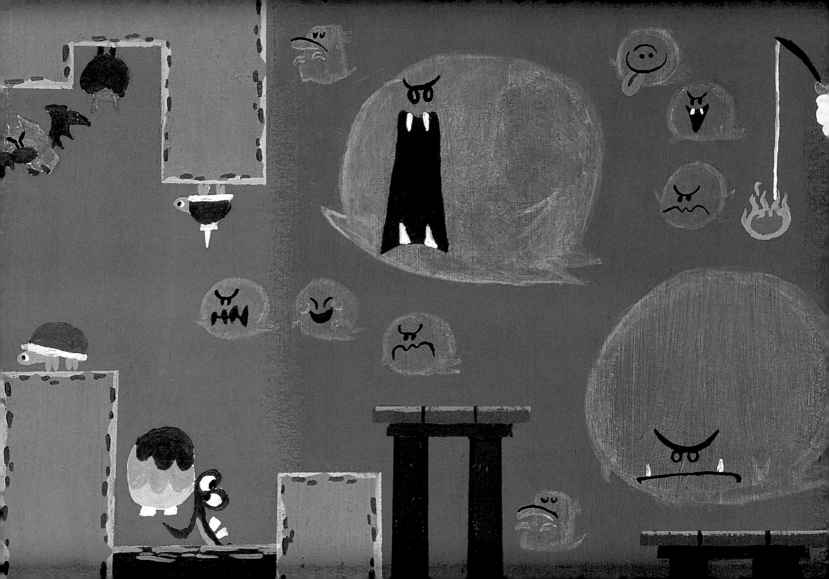

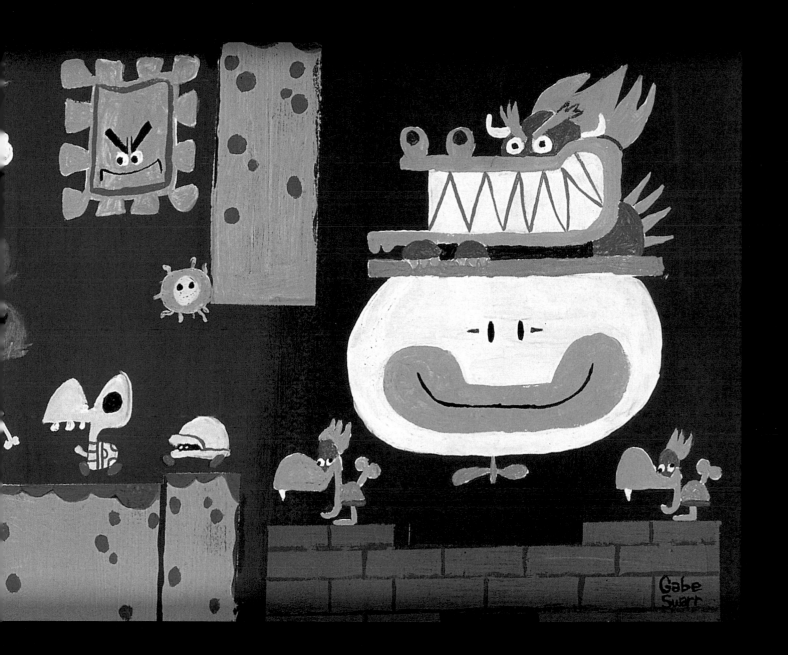

07300

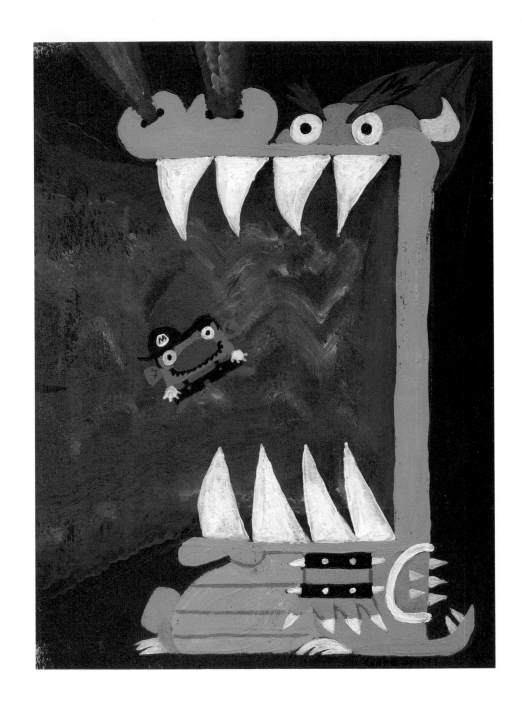

07400

Gabe Swarr
Bowser Breath
acrylic on illustration board - 7½ x 9½ inches
Inspiration: *Super Mario Bros.* (NES)

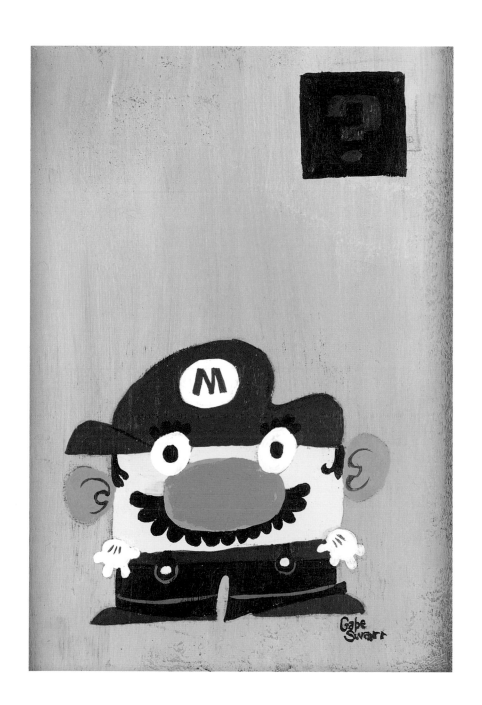

Gabe Swarr
Mario Block
acrylic on illustration board - 5 x 7 inches
Inspiration: *Super Mario Bros. 3* (NES)

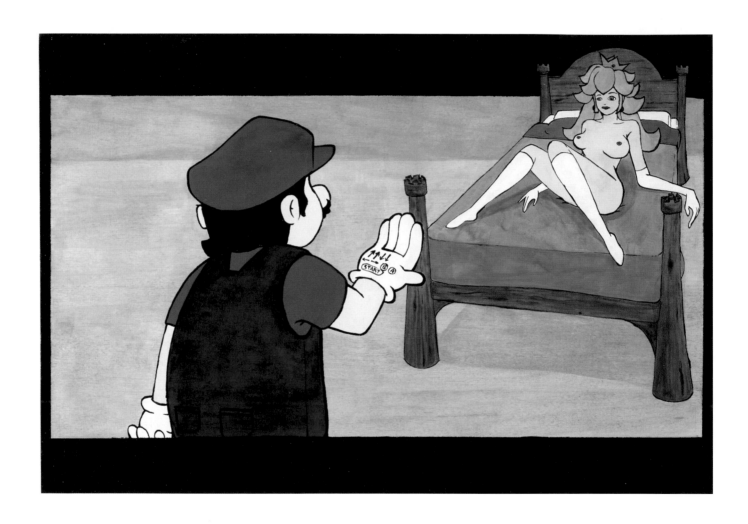

07800 **Jason Sho Green**
Putting the Super in Mario (diptych)
acrylic on wood - 16 x 10¾ inches / 5½ x 5½ inches
Inspiration: *Contra* (NES), *Super Mario Bros.* (NES)

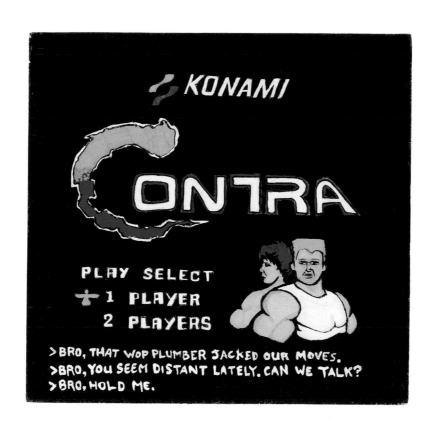

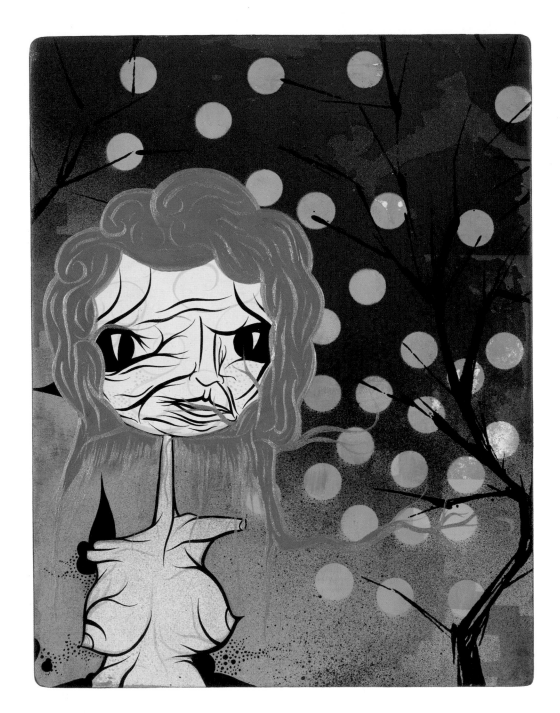

08000 **Joshua Krause**
The Lovely Ms. Pac-Man in Her Final Days
acrylic, stain, collage, and aerosol on wood - 10 x 12½ inches
Inspiration: *Ms. Pac-Man* (arcade)

Videogames are the culmination of these ideas: **SAVE THE PRINCESS, EAT THE DOTS, JUMP FROM HERE TO THERE, AND FOLLOW YOUR ZANY DREAMS...**

—Joshua Krause

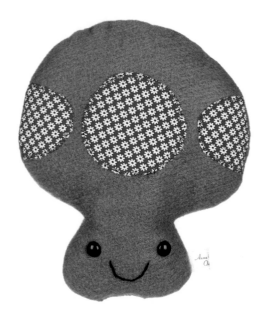
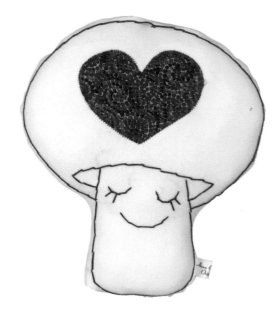
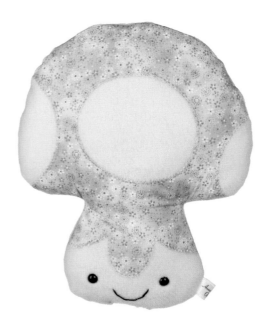
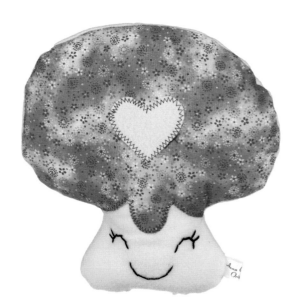

Anna Chambers
Mushroom 1, 2 (top row)
stuffed, mixed media - 8 x 8 inches
Inspiration: *Super Mario Bros.* (NES)

Anna Chambers
Mushroom 3, 4 (bottom row)
stuffed, mixed media - 8 x 8 inches
Inspiration: *Super Mario Bros.* (NES)

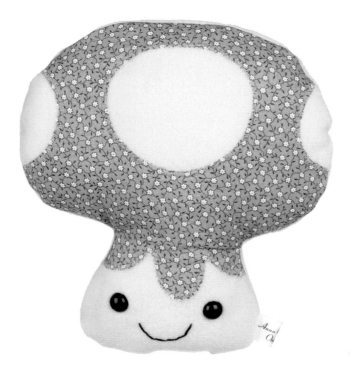

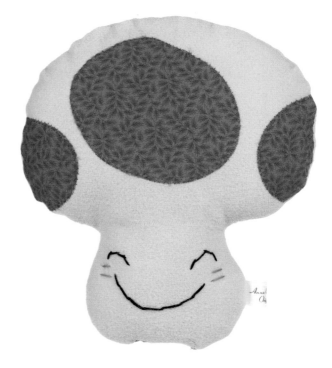

Anna Chambers
Mushroom 5
stuffed, mixed media - 9½ x 8½ inches
Inspiration: *Super Mario Bros.* (NES)

Anna Chambers
Mushroom 6
stuffed, mixed media - 9½ x 8½ inches
Inspiration: *Super Mario Bros.* (NES)

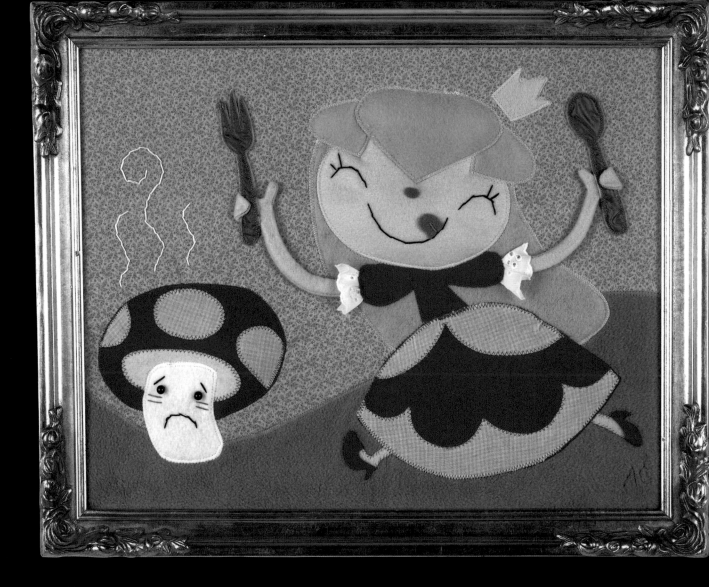

08400 **Anna Chambers**
Lunch Time for Peach
stuffed, mixed media - 22½ x 18½ inches
Inspiration: *Super Mario Bros.* (NES)

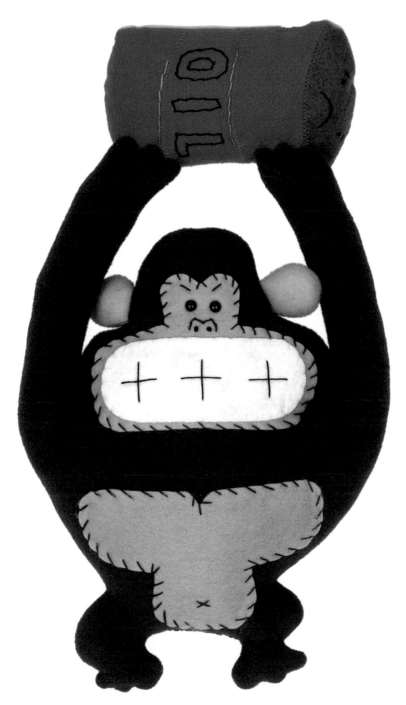

Anna Chambers
Donkey Kong with Barrel
stuffed, mixed media - 21 x 12 inches
Inspiration: *Donkey Kong* (arcade)

08500

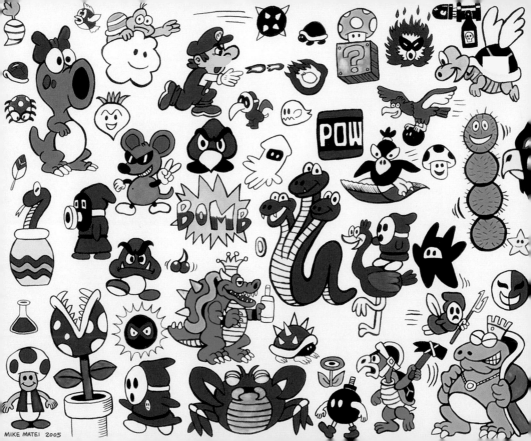

POW

BOMB

MIKE MATEI 2005

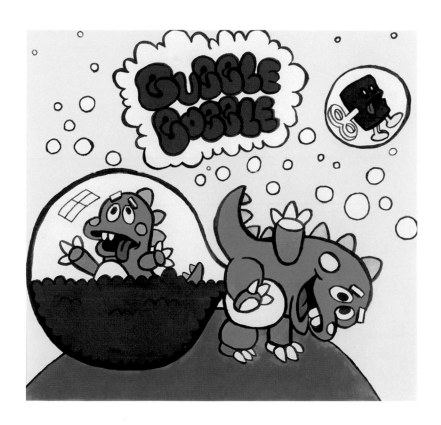

Mike Matei
Bubble Bobble
gouache and ink on bristol board - 9 x 8¼ inches
Inspiration: *Bubble Bobble* (NES)

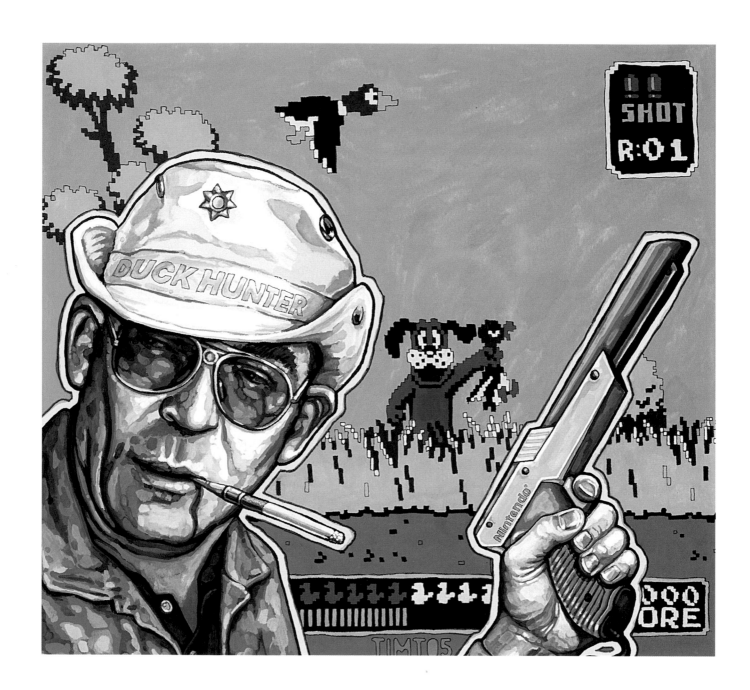

08800 **Tim Tomkinson**
 Duck Hunter S. Thompson
 gouache, ink, and pencil on canvas - 8¼ x 7½ inches
 Inspiration: *Duck Hunt* (NES)

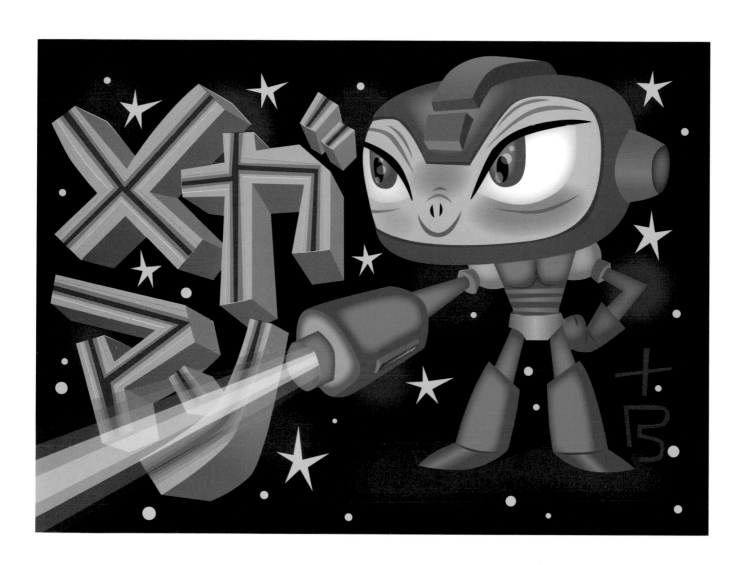

Tim Biskup
Mega Man
digital - 8 x 11 inches
Inspiration: *Mega Man* (NES)

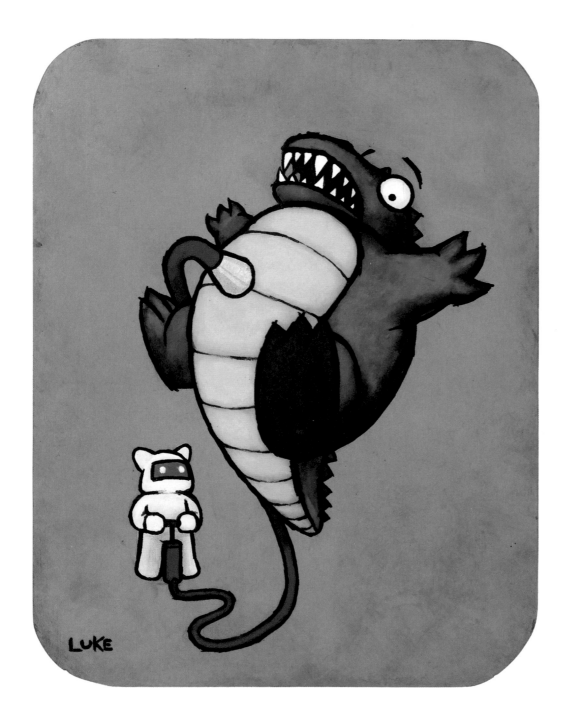

09000 **Luke Chueh**
Dig Dug
acrylic and ink on canvas - 11 x 14 inches
Inspiration: *Dig Dug* (arcade)

Dig Dug featured an intriguingly disturbing element—the method you use to destroy your enemies. Armed with a bicycle pump, you simply shoot its nozzle into your foes and pump them full of air until they explode. When you actually play the game, its chunky graphics really don't make what's going on evident, but **IF YOU TAKE THE TIME TO THINK ABOUT IT, YOU MUST AGREE THAT BEING INFLATED 'TIL YOU EXPLODE WOULD BE TERRIBLY UNPLEASANT.**

—Luke Chueh

09200 **JJ Stratford**
720
c-print photo - 28 x 24 inches
Inspiration: *720°* (arcade)

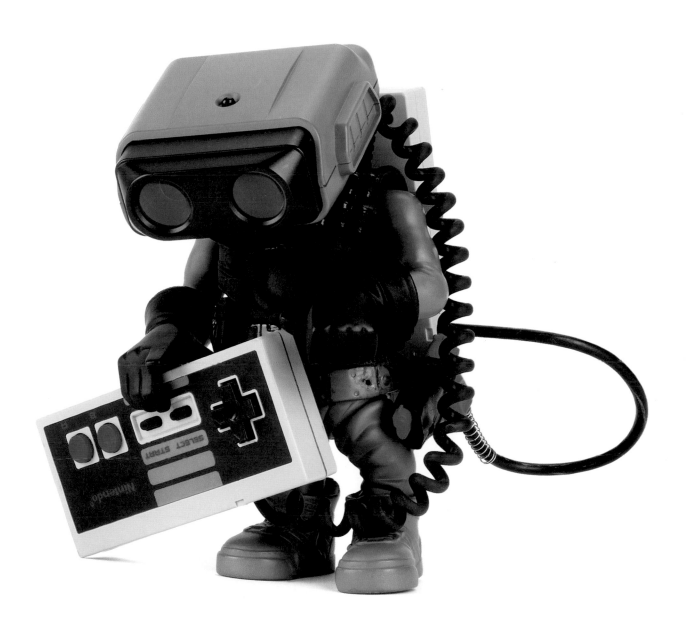

Trent Watanabe
8-Bit: One
mixed media - 7½ x 7 inches
Inspiration: *Gyromite* (NES)

09300

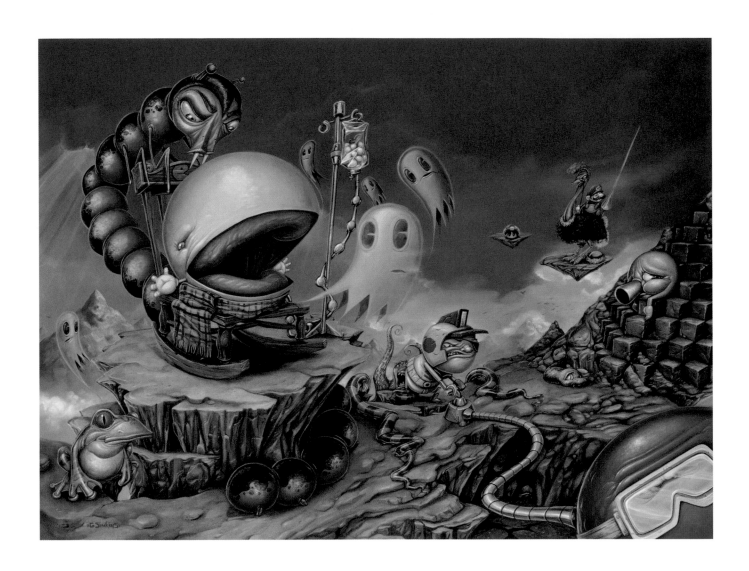

09400 **Greg "Craola" Simkins**
Pac-Man in Hospice
acrylic on canvas - 24 x 18 inches
Inspiration: *Centipede, Dig Dug, Frogger, Joust, Super Mario Bros.* (all NES); *Pac-Man* (arcade)

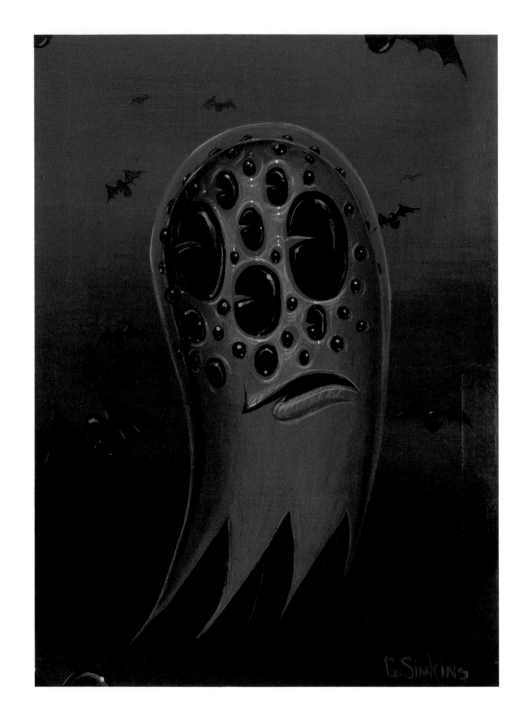

09600

Greg "Craola" Simkins
Blinky
acrylic on wood panel - 5 x 7 inches
Inspiration: *Pac-Man* (arcade)

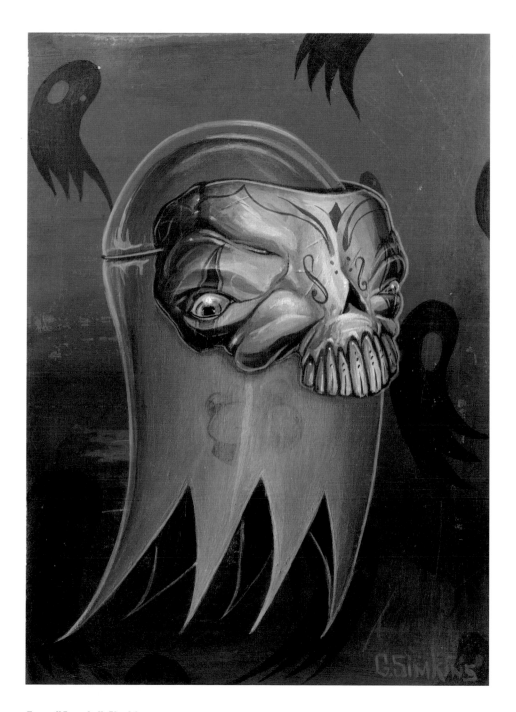

Greg "Craola" Simkins
Clyde
acrylic on wood panel - 5 x 7 inches
Inspiration: *Pac-Man* (arcade)

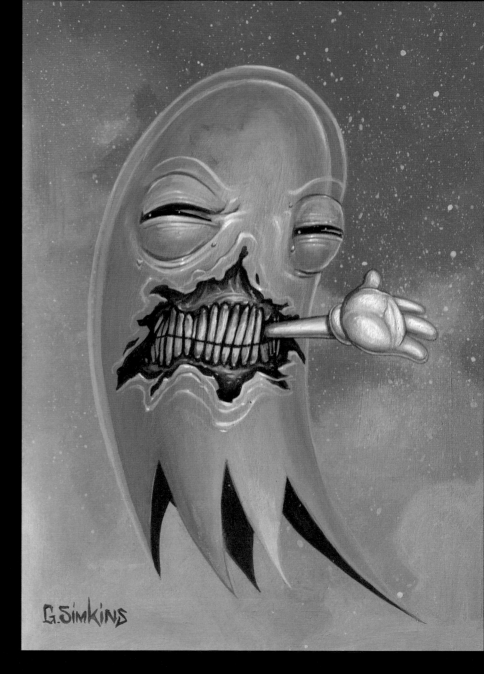

Greg "Craola" Simkins
Pinky
acrylic on wood panel - 5 x 7 inches
Inspiration: *Pac-Man* (arcade)

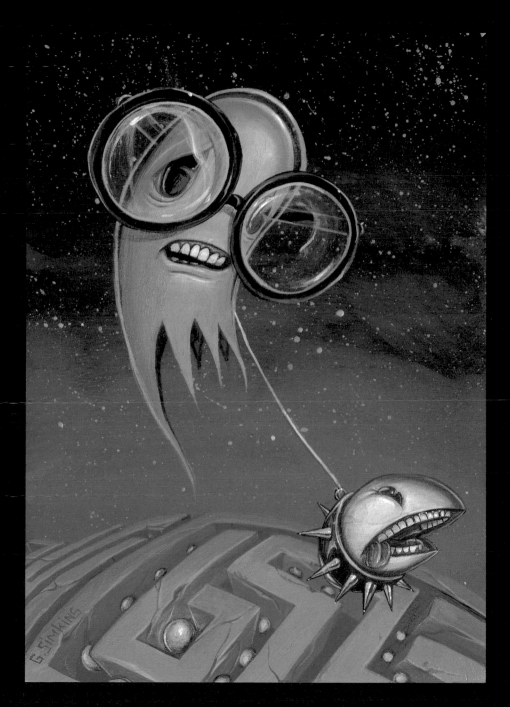

Greg "Craola" Simkins
Inky
acrylic on wood panel - 5 x 7 inches
Inspiration: *Pac-Man* (arcade)

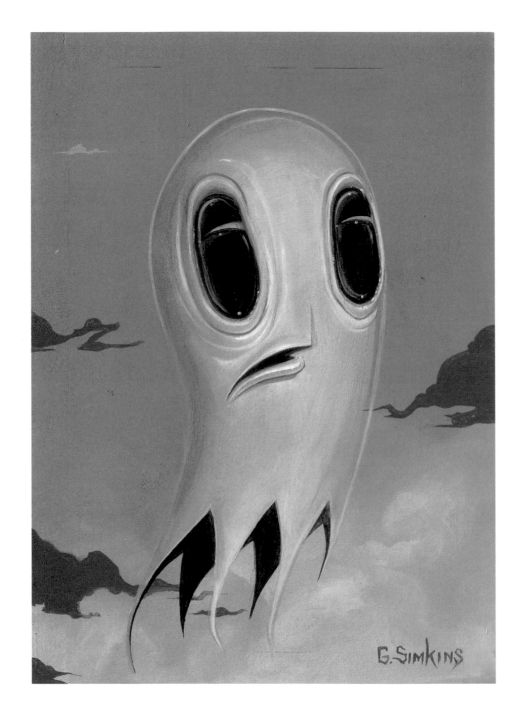

10000 **Greg "Craola" Simkins**
R.I.P. Ghost
acrylic on wood panel - 5 x 7 inches
Inspiration: *Pac-Man* (arcade)

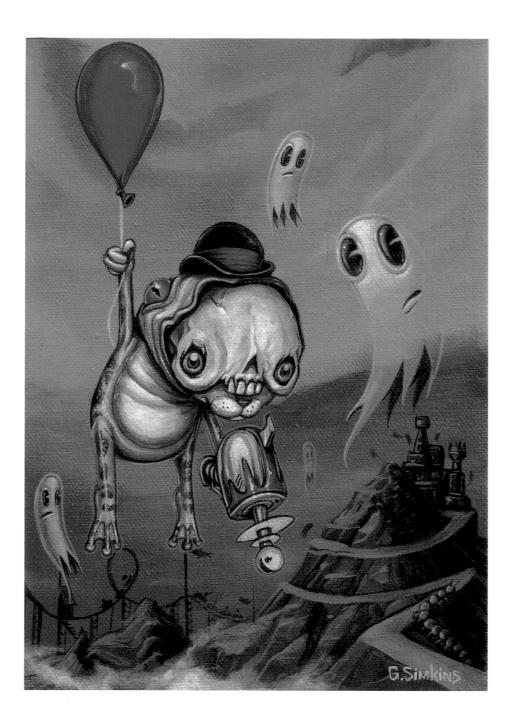

Greg "Craola" Simkins
Frogger Ghost Hunter
acrylic on canvas - 6 x 8 inches
Inspiration: *Frogger* (arcade)

STREET FIGHTER II WAS THE MOST PAINLESS WAY TO EARN HONOR AND ADMIRATION— AT LEAST FOR AN ELEVEN-YEAR-OLD IN MEXICO CITY. In every arcade with a **SF2** machine, you could witness all the struggles of life: the rich versus the poor; the North versus the South; the first world versus the third world; and, more importantly, you versus thousands of unknown kids.

As a proud Mexican boy, I had to swear my loyalty to any Mexican character. Sadly, there were none. The closest I could come was Blanka, a Brazilian monster with green fur and crazy orange hair. So I trained until I felt orange hair coming out of my chest... but someone—usually younger—could always put me in my place. When I got into real fights, I even tried using some of his moves. They never worked.

—Jorge R. Gutierrez

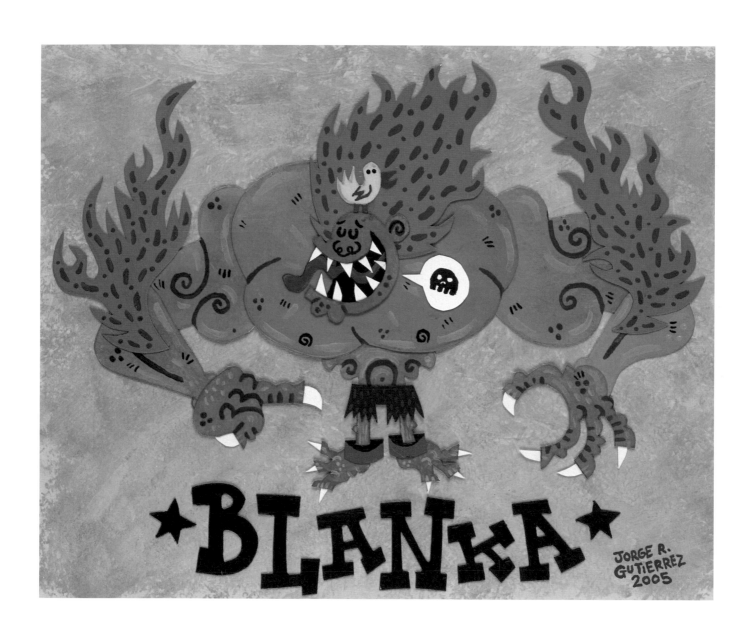

Jorge R. Gutierrez
Bossa Nova Blanka
acrylic on watercolor paper - 10 x 8 inches
Inspiration: *Street Fighter II* (SNES)

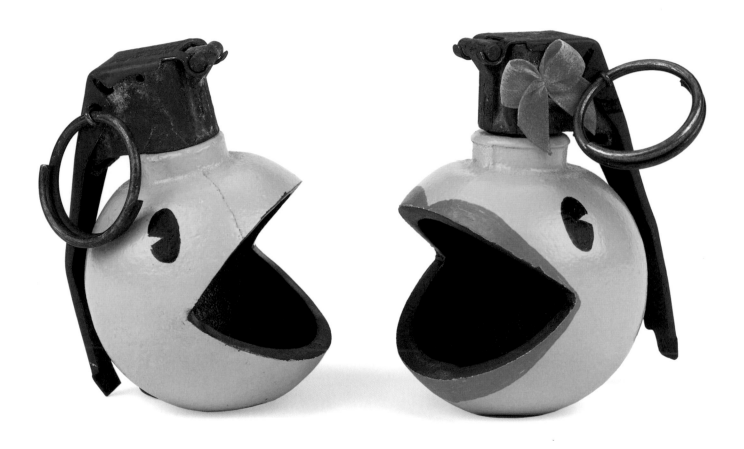

10400 **Peter Gronquist**
Untitled
grenades - 3 x 4 inches (each)
Inspiration: *Pac-Man* (arcade)

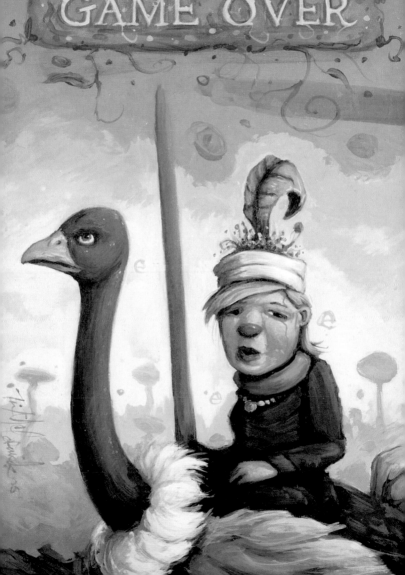

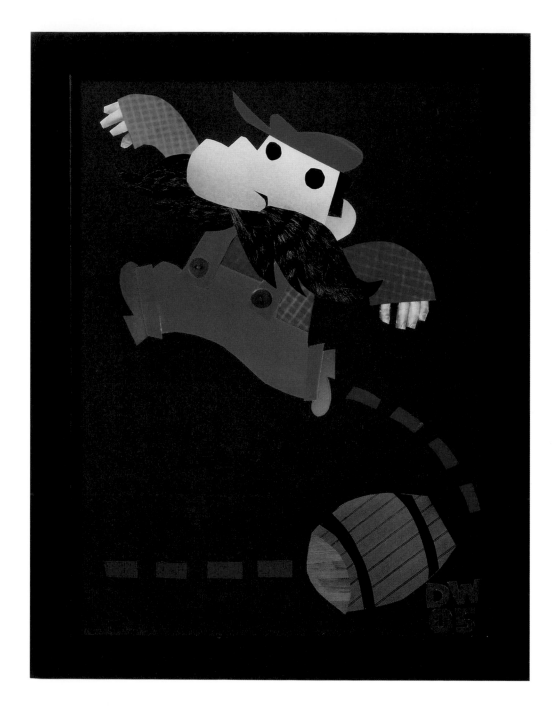

10600

Dave Wasson
Mario: The Early Years
mixed media - 10¼ x 13¼ inches
Inspiration: *Super Mario Bros.* (NES)

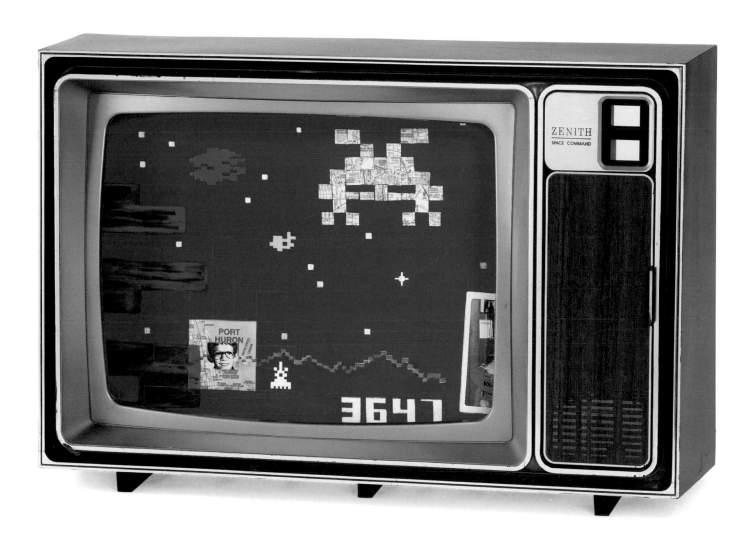

David Knott
3647 Thornton
acrylic and collage on canvas - 25 x 15 inches
Inspiration: *Astrosmash* (Intellivision)

10700

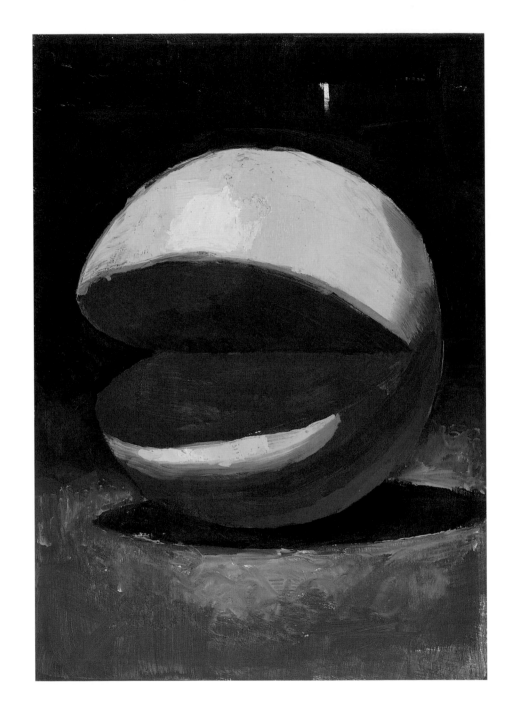

10800

Nathan Stapley
Pac-Man
oil on panel - 5 x 7 inches
Inspiration: *Pac-Man* (arcade)

Nathan Stapley
Q*bert
oil on panel - 5 x 7 inches
Inspiration: *Q*bert* (arcade)

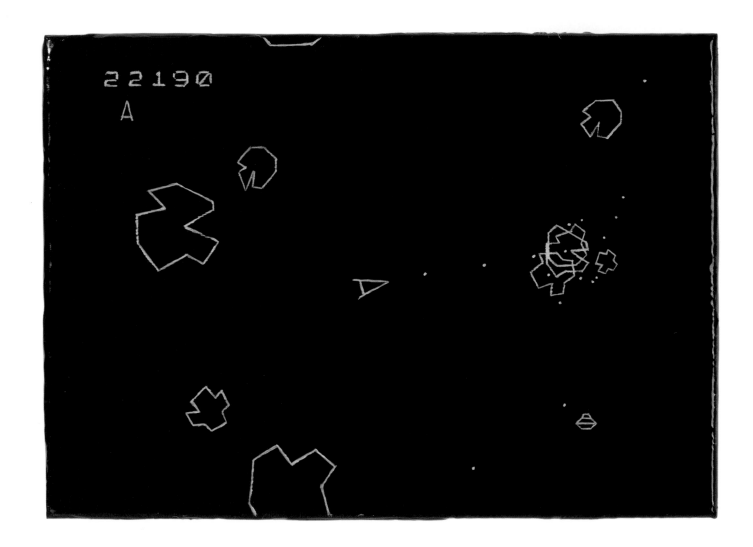

11000 **Nathan Stapley**
Asteroids
mixed media on panel - 7 x 5 inches
Inspiration: *Asteroids* (arcade)

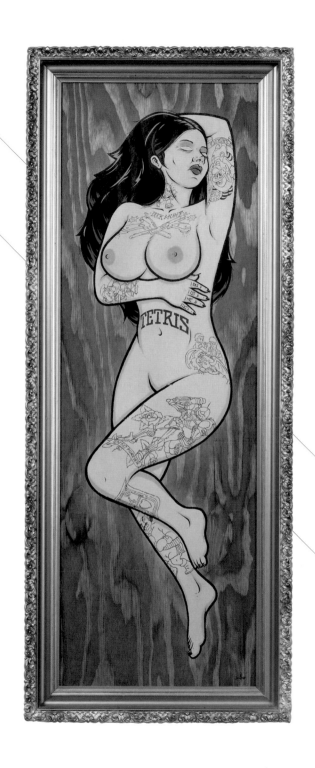

Todd Bratrud
Up, Down, Up, Down, Left, Right,
Left, Right, A, B, A, B, Select, Start
acrylic on wood - 18½ x 47 inches
Inspiration: *Double Dragon, Duck Hunt, The Legend
of Zelda, Mega Man, Metroid, Mike Tyson's Punch-
Out!!, Super Mario Bros. 3, Tetris* (all NES)

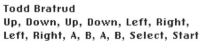

11100

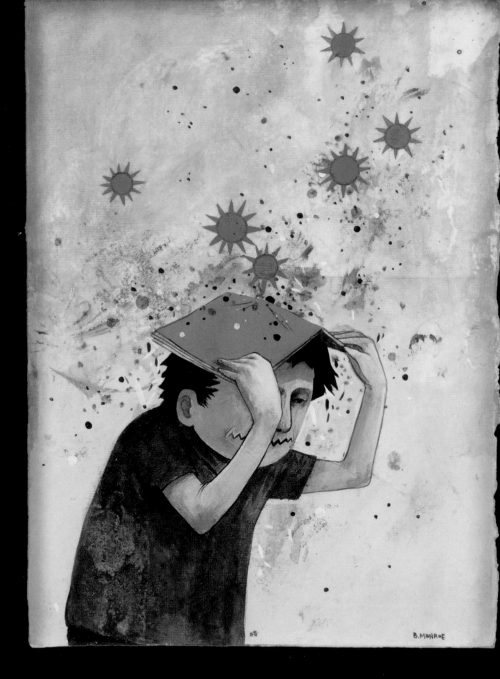

11200

Brendan Monroe
They'll Hurt If They Fall on Me
acrylic on paper - 8 x 10 inches

Deth P. Sun
Untitled
acrylic on wood - 17 x 18 inches
Inspiration: *Space Invaders* (arcade); *Tetris* (NES)

There are millions of things in the world that need to get done, and each one of those things "chooses" a person to do it. I thought it would be funny to explore this perspective through something seemingly trivial, like an arcade game. The game has selected the man to be its ambassador. This kind of thing is universal, though—**EVERYONE IS THE AMBASSADOR OF SOMETHING; YOU JUST HAVE TO DISCOVER WHAT IT IS.**

—Matt Clark

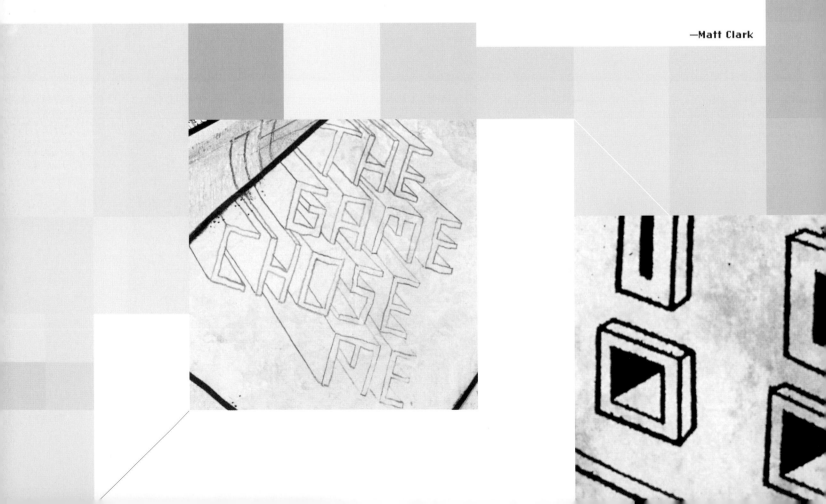

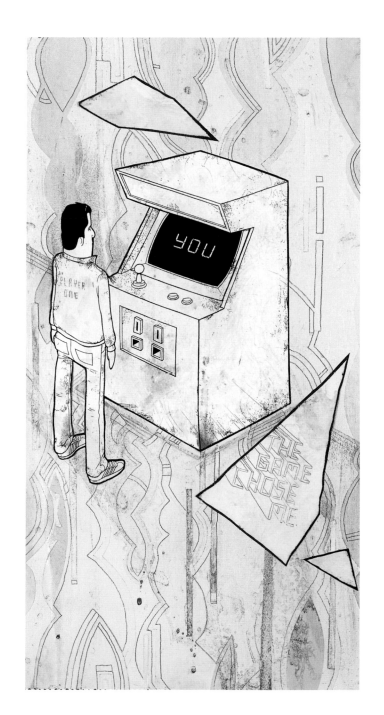

Matt Clark
The Game Chose Me
mixed media - 7½ x 14 inches
Inspiration: arcades

11500

11600 **Plasticgod**
 Sark
 digital print on canvas - 4 x 4 inches
 Inspiration: *Tron* (arcade)

Plasticgod
Tron
digital print on canvas - 4 x 4 inches
Inspiration: *Tron* (arcade)

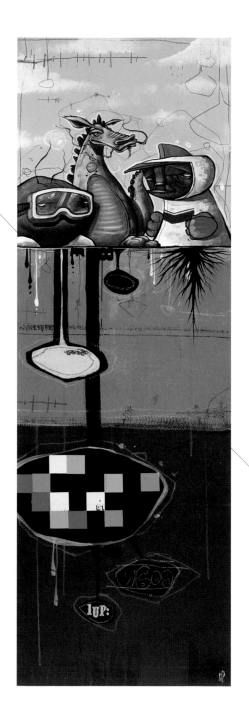

11800

Blaine Fontana
Dig Dug
mixed media on canvas - 15 x 45 inches
Inspiration: *Dig Dug* (arcade)

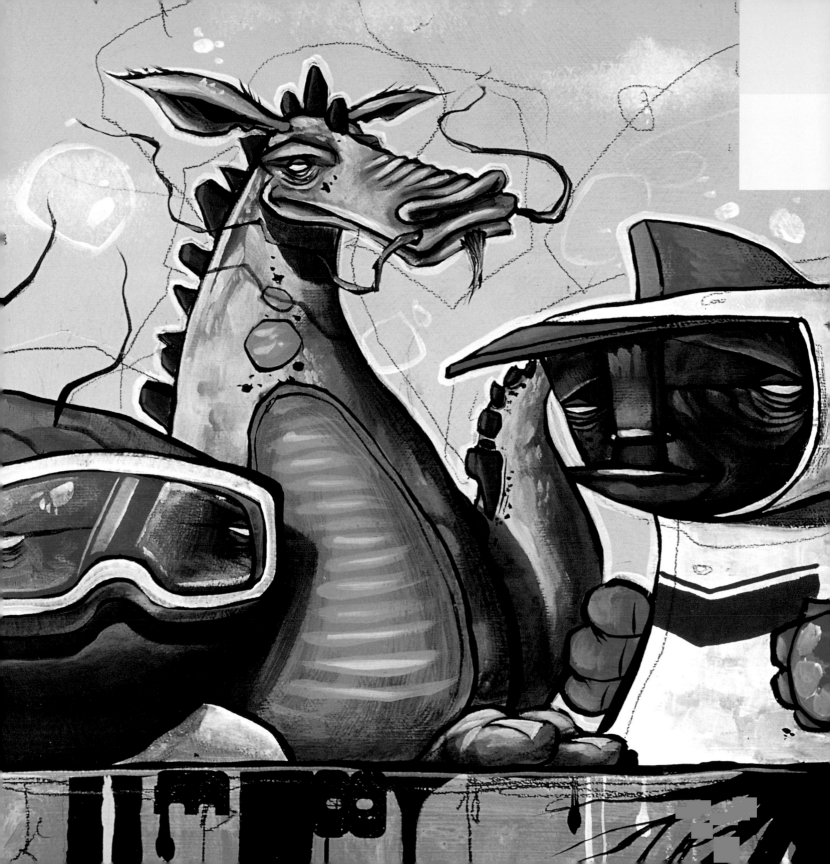

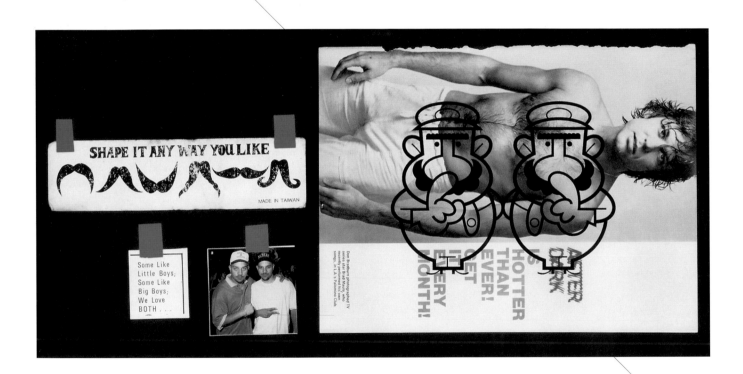

12000 **Chip Wass**
 Super Mario Lovers
 mixed media - 22 x 12 inches
 Inspiration: *Super Mario Bros.* (NES)

I would fantasize of the glamorous life I would have when I grew up and lived in New York City: primarily, all-night disco dancing with handsome mustachioed men. This fantasy is not far from my current reality. I have a mustache. It's kind of gay porn star—but it's also kind of **Super Mario Bros.** THIS MAKES ME WONDER . . . IF THE MARIO BROTHERS HAVE ANY SEX LIFE TO SPEAK OF, THEY'RE BEING VERY 'DON'T ASK / DON'T TELL' ABOUT IT.

—Chip Wass

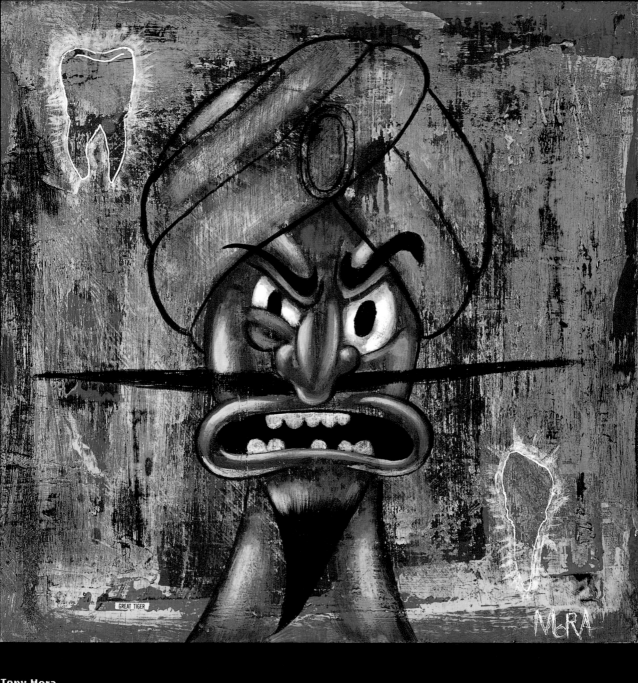

Tony Mora
Great Toothless Tiger
acrylic on wood - 8 x 8 inches

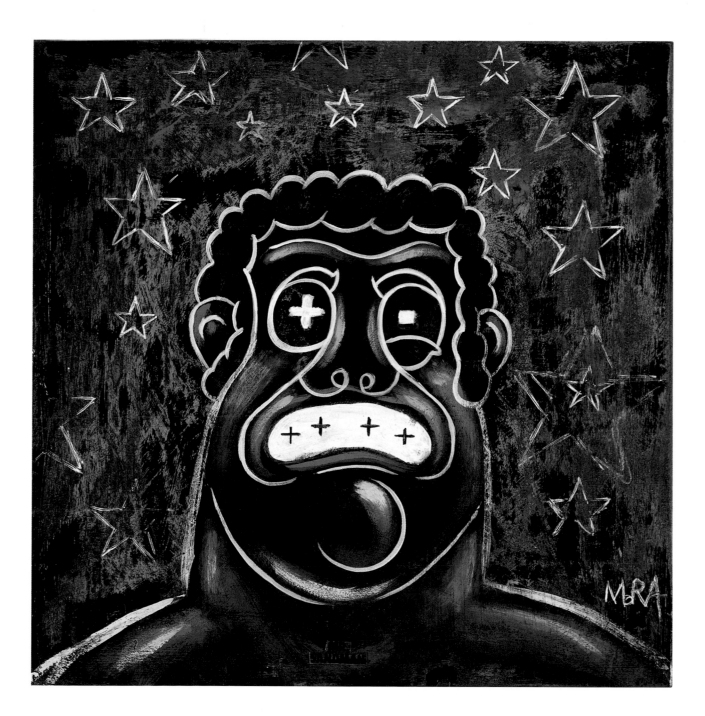

Tony Mora
Sleepy Time for Mr. Sandman
acrylic on wood - 8 x 8 inches
Inspiration: *Mike Tyson's Punch-Out!!* (NES)

12300

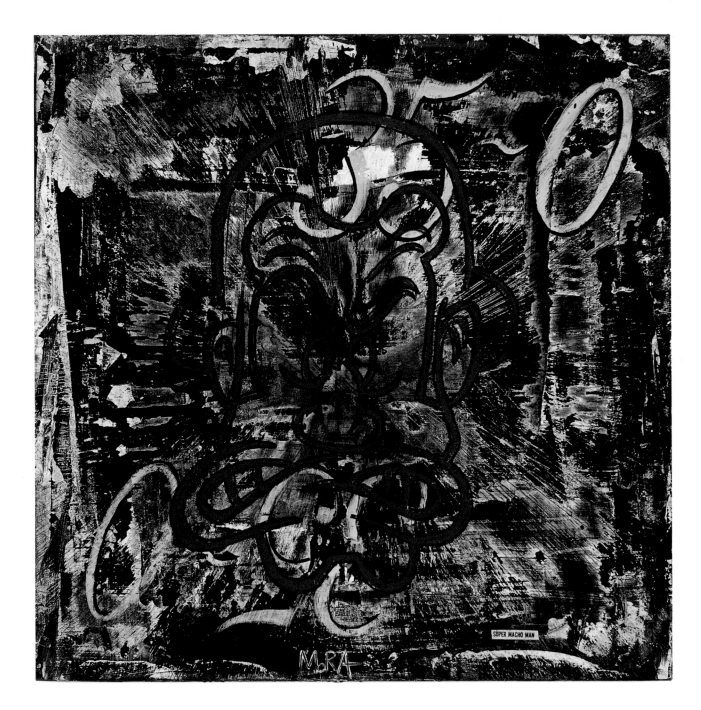

SÚPER MACHO MAN

MORA

12400 **Tony Mora**
 35-0
 acrylic on wood - 8 x 8 inches
 Inspiration: *Mike Tyson's Punch-Out!!* (NES)

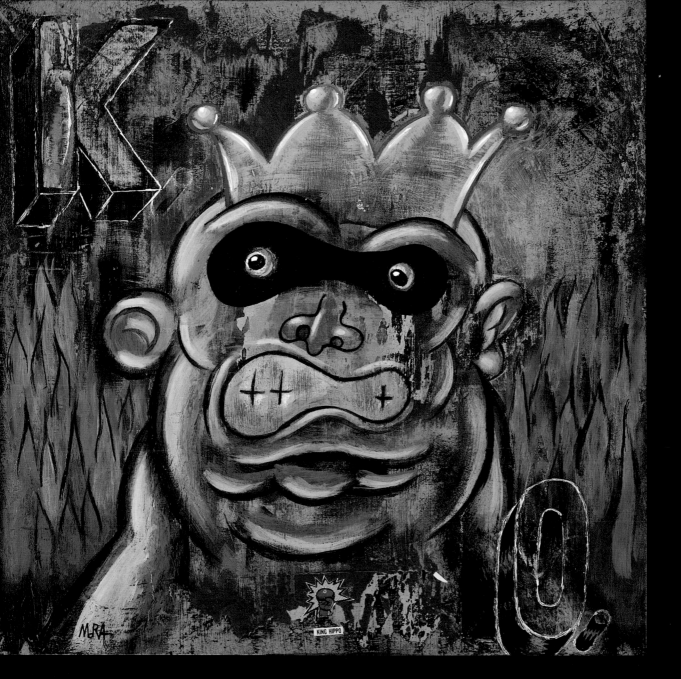

Tony Mora
k.h., k.o.'d
acrylic on wood - 8 x 8 inches
Inspiration: *Mike Tyson's Punch-Out!!* (NES)

12500

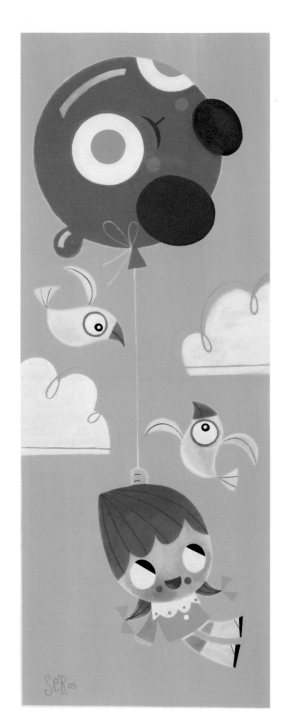

Sandra Equihua
Kirby, Take Me Away!!
acrylic on illustration board - 6 x 15 inches
Inspiration: *Kirby's Adventure* (NES)

12600

Devin Crane
An Old Reflection
acrylic and colored pencil on illustration board - 8 x 10 inches
Inspiration: *Super Mario Bros.* (NES)

12700

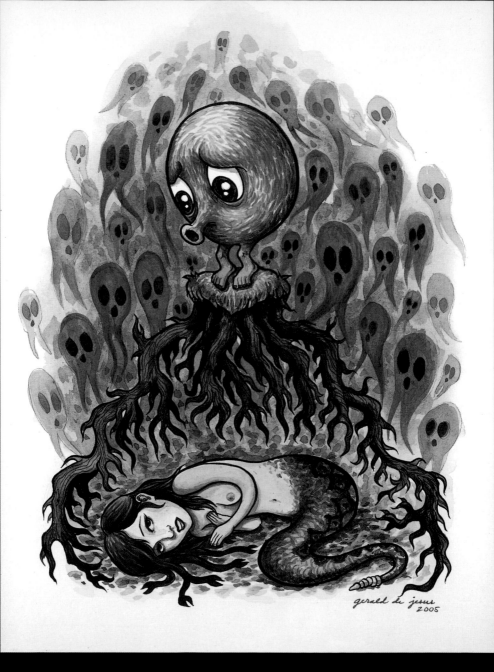

Gerald De Jesus
Catharsis
ink and watercolor on paper - 18½ x 22 inches
Inspiration: *Q*bert* (arcade)

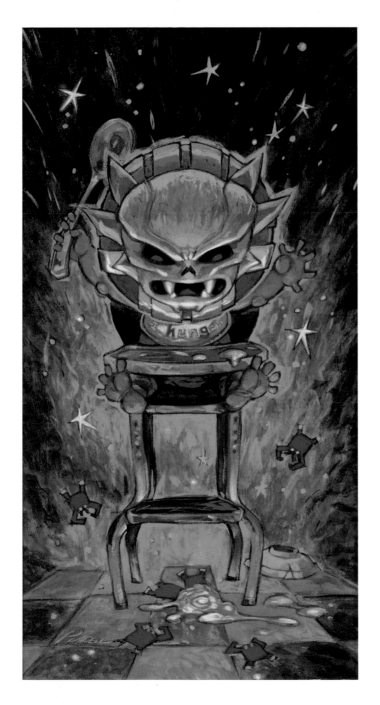

Steve Purcell
I Hunger
acrylic on board - 7 x 13 inches
Inspiration: *Sinistar: Cradle to Grave* series (arcade)

In PAC-MAN, the four ghosts always come across as having the same qualities, but some must be better than others. **THERE MUST BE A HAPPY-HAPPY, JOY-JOY MOMENT WHEN, LET'S SAY, ONLY ONE OF THESE GHOSTS GETS PAC-MAN. EATS HIM UP. THAT MUST BE SATISFYING.** Pac-Man loses; the ghost wins. This is the trigger to richer experience—a deep satisfaction. And I suppose it's an almost spiritual thing, a simple, 8-bit transcendence where it just reveals itself, where the ghost has this nirvana moment that ancient mystics and books on tape can teach us today.

—Daniel Pea●

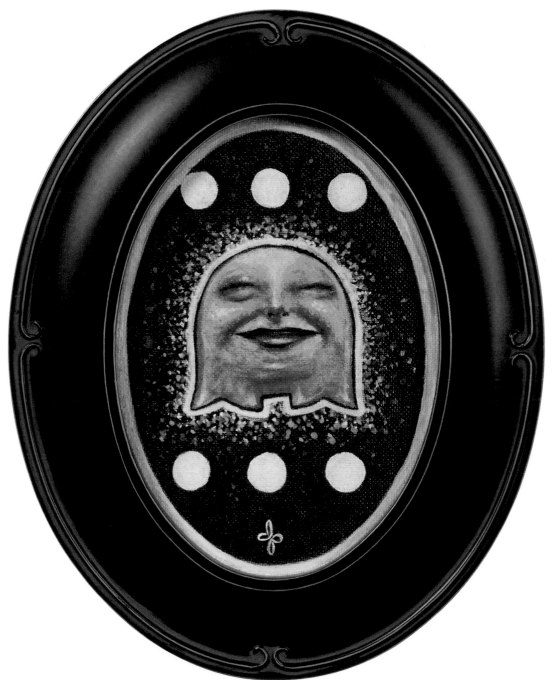

Daniel Peacock
PacMantra; or, Inner Tranquility and Wholeness of Being After Eating That Pac-Man Bastard
acrylic and oil on canvas - 4¾ x 6½ inches
Inspiration: *Pac-Man* (arcade)

13100

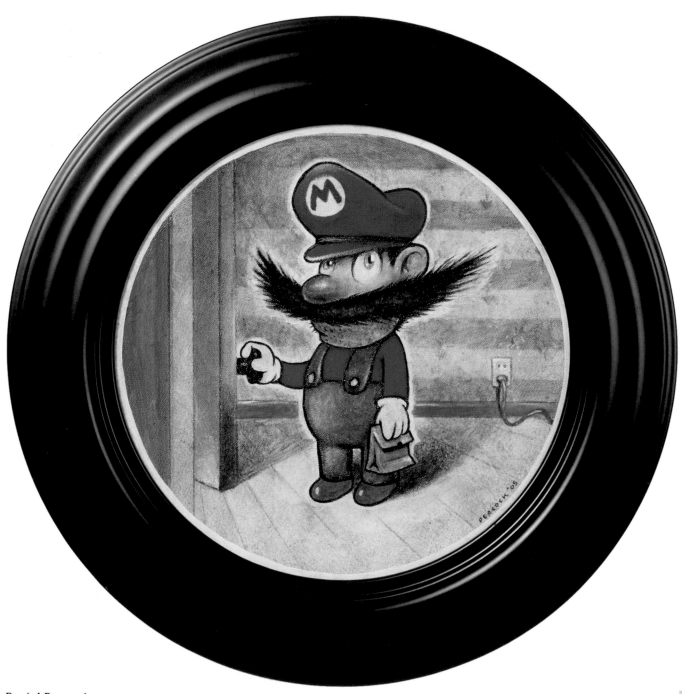

13200 **Daniel Peacock**
 Super Mario Sack Lunch
 acrylic and oil on canvas - 12 inches
 Inspiration: *Super Mario Bros.* (NES)

Early every morning—to save a little money—S. Mario makes his lunch at home and takes it to work in a brown bag. **TODAY HE'S HAVING A SANDWICH OF BLACK FOREST HAM ON CRACKED WHEAT WITH MUSTARD SAUCE AND A SIDE PICKLE—WITH CHIPS.**

—Daniel Peacock

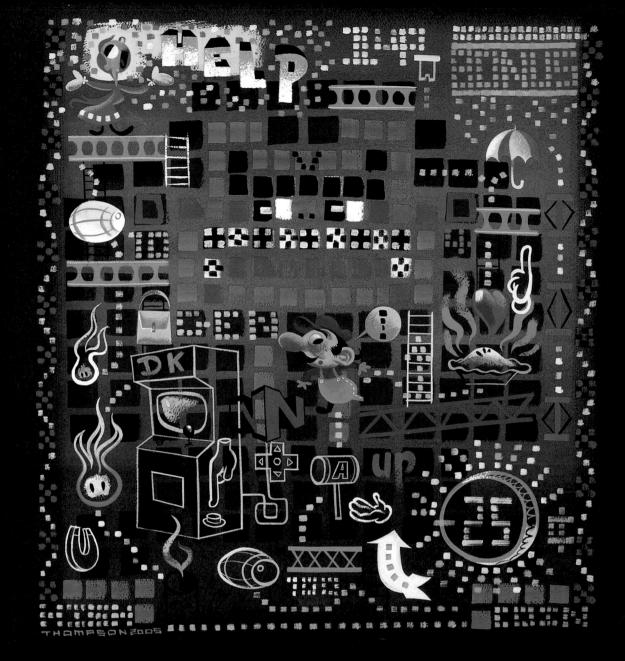

13400 Miles Thompson
NGEN@81
gouache on paper - 19 x 19 inches
Inspiration: *Donkey Kong* (arcade)

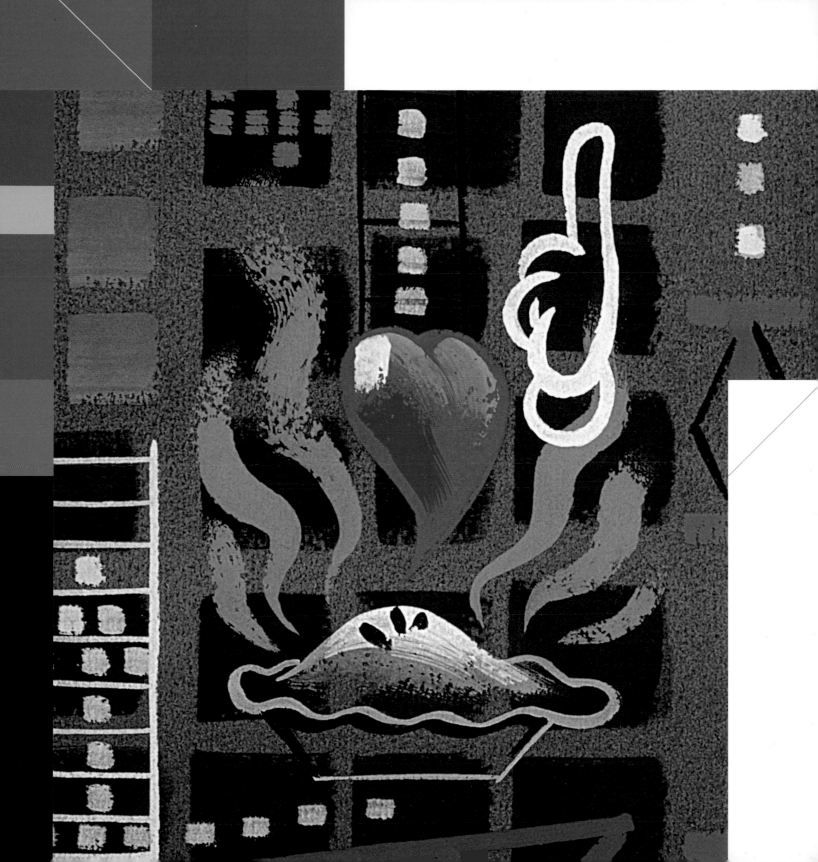

13600 **Dave Crosland**
Zelda
acrylic, marker, watercolor, and colored pencil on paper - 15 x 6 inches
Inspiration: *The Legend of Zelda* (NES)

13700

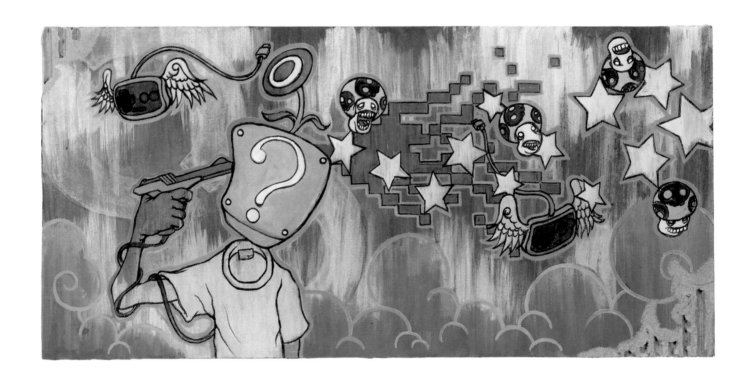

13800 **Yoskay Yamamoto**
 Untitled
 acrylic on cardboard - 18 x 10½ inches
 Inspiration: *Duck Hunt* (NES), *Super Mario Bros.* (NES)

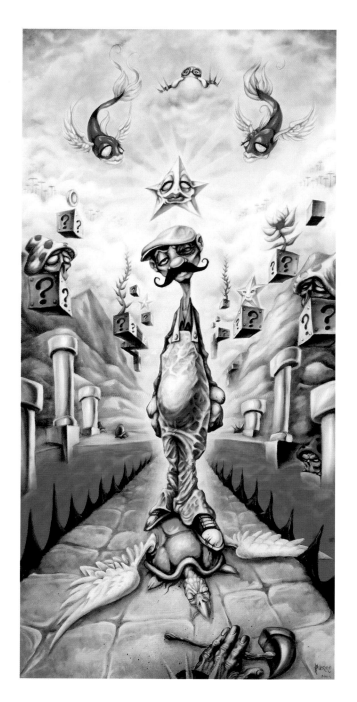

Isaac Pierro
Don't Be a 2nd Player Hater (Luigi for Sheezy)
Krylon and oil on canvas - 23 x 40½ inches
Inspiration: *Super Mario Bros. 2* (NES)

13900

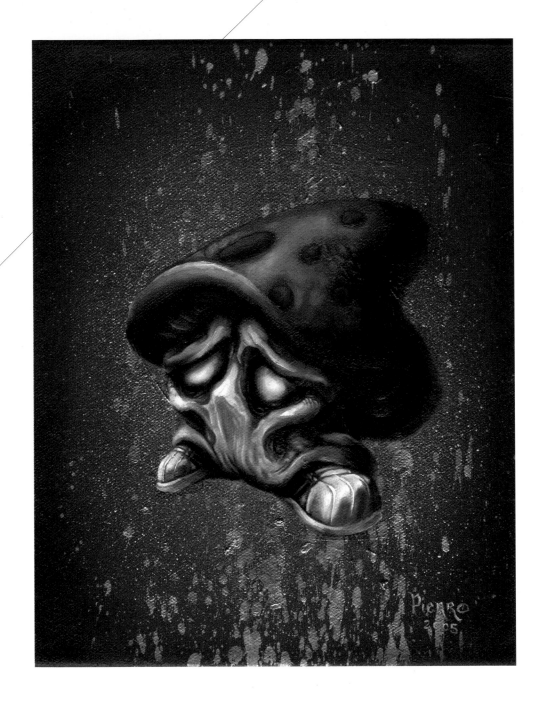

14000

Isaac Pierro
Ooh, Getchyo Big!!!
Krylon and oil on canvas - 13 x 16 inches
Inspiration: *Super Mario Bros.* (NES)

A CERTAIN EXCITEMENT WOULD TAKE OVER THE ROOM WHENEVER SOMEONE BUMPED A SQUARE THAT HAD A MUSH-ROOM—MAKING YOU BIG—prompting the crowd to yell, "OOH, OOH, GETCHYO BIG!!!" and you had to get your big mushroom before it fell off the screen.

—Isaac Pierro

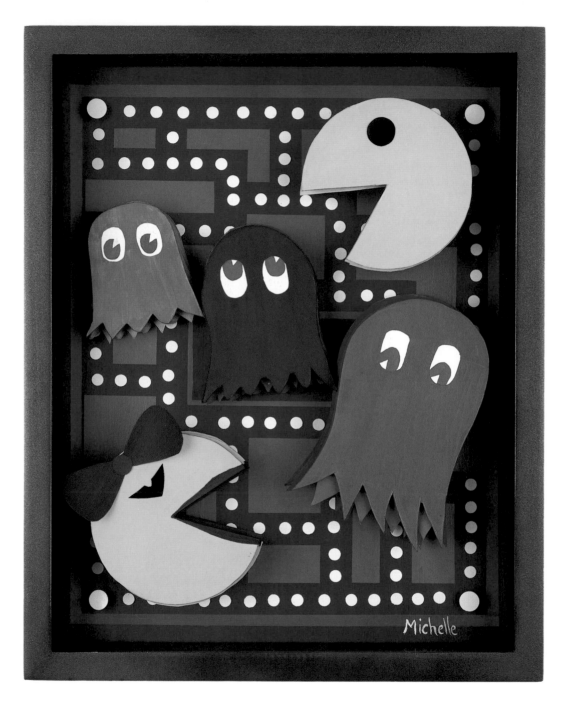

14200

Michelle Garduno
Tag Team
mixed media - 11¾ x 14¾ inches
Inspiration: *Ms. Pac-Man* (arcade), *Pac-Man* (arcade)

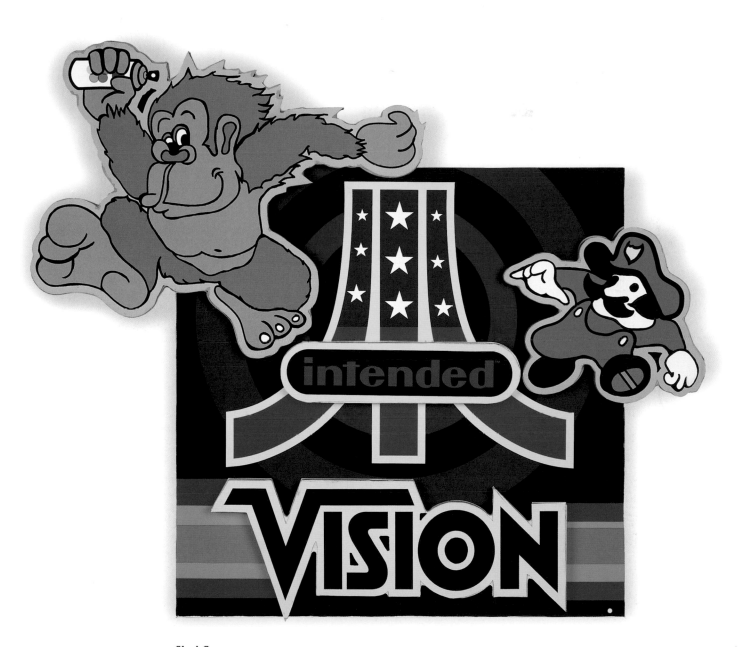

Sket One
Intended Vision
acrylic and digital print on gator board - 32 x 27 inches
Inspiration: Activision, Atari, *Donkey Kong* (arcade), Nintendo

14300

Sket One
Insert Coin
Acrylic and digital print on canvas - 20 x 30 inches
Inspiration: arcades

Sket One
2 Much @!#?@!
acrylic and digital print on wood with screen-printed frame - 23 x 21 inches
Inspiration: *Mr. Do* (arcade), *Q*bert* (arcade)

14500

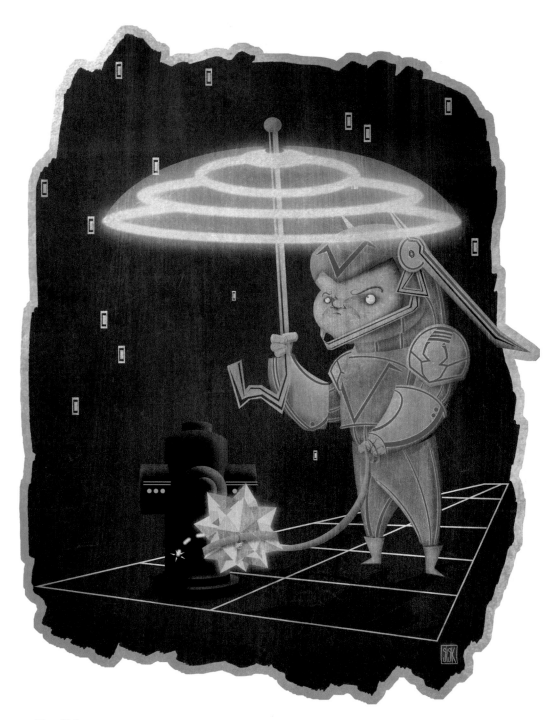

14600

Clay Sisk
Bit Break
mixed media - 12½ x 16½ inches
Inspiration: *Tron* (arcade)

GAME OVER

HIGH SCORES

LOVE ABLAN 05800

Los Angelino Ms. Ablan is a multimedia artist, photographer, designer, and creator of other splendored things. Her work has appeared in galleries around the world, in the character design book **Pictoplasma 2**, and possibly even in your home. **www.loveablan.com**

KII ARENS 06200

Mr. Arens is a pop-art designer with a bent toward rock 'n' roll. Never formally trained, this St. Paul, Minnesota, native grew up with a fascination for album covers, band logos, blinding color combos, and Sid and Marty Krofft's Saturday morning creations. **www.kiiarens.com**

SHAWN BARBER 06400

Illustrator, painter, web designer, teacher, and all-around make-shit-happen guy, Mr. Barber moved to San Francisco two summers ago with his wife, Yukiko, and their cat, Miles, to enjoy the hills, the food, the fog, and the fabulous art scene.

GARY BASEMAN 01900

Pervasive artist. Painter. TV and movie producer. Toy designer. Humorist. Mr. Baseman is all these and continues to have solo exhibitions of his paintings in New York, Los Angeles, Rome, and Tokyo. **www.garybaseman.com**

TIM BISKUP 08900

Mr. Biskup's dense, character-driven style is inspired by mid-century modern design infused with a healthy dose of punk-rock energy. He owns his own store/gallery, Bispop Gallery, in Old Town Pasadena, California, exhibiting and selling original paintings, clothing, toys, books, cards, and other cool, exclusive stuff. **www.timbiskup.com**

TODD BRATRUD 11100

Crookston, a small beet-farming town in rural northern Minnesota, is where Mr. Bratrud began life. Now living in Santa Cruz, California, he's divided between art directing for skate companies and showing his art. **www.burlesquedesign.com**

RYAN BUBNIS 04800

In a world full of bunnies, bears, vampires, and superheroes, Mr. Bubnis's characters play and reach beyond the realm of normal cartoon caricature to express a broad range of human emotions, like bravery, sadness, loneliness, and joy. He resides in Portland, Oregon. **www.ryanbubnis.com**

NATHAN CARTWRIGHT 02700

Mr. Cartwright came from deceivingly humble beginnings, spawned from the urban blight of the central Ohio flatlands. Currently, the shaman artist is living in Los Angeles, simply a pause for realignment and social and artist connecting. **www.artwrightstudios.com**

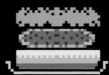

MARTIN CENDREDA 06600

32. Cartoonist. Animator. Los Angeles. Pizza. Blue. Wife: Jenny. Cats: Snuggins, Monkey. Shoe: 8½.
www.zurikrobot.com

ANNA CHAMBERS 08200

Lovely Ms. Chambers was born in Santa Barbara, California, but calls smoggy Los Angeles home sweet home. She draws cartoons by day, sews plush creatures by night, and just generally tries to instill the world with cuteness at every corner.
www.annachambers.com

LUKE CHUEH 09000

Mr. Chueh (pronounced **Chu**—not **Chewy**) brush 'n' inked his way through Los Angeles's alternative art scene with visions of cute but brute creatures always in seemingly ill-fated situations. Poor animals—they did nothing.
www.lukechueh.com

SEAN CLARITY 02400

Mr. Clarity day-jobs graphics at Movingsun Studios and moonlights as art director at HipHopSite.com. He has learned to keep his profession a secret from women, because women who would want to date an artist must be crazy. If anyone asks, he's the top salesman at the Carpet Barn, three years running.
www.faok.com

MATT CLARK 11400

You wouldn't know it from looking at any of his work, but Mr. Clark is the Ernest Hemingway of our time. He's not alcoholic or anything, but he's definitely bearded and surly, living out his existence in Portland, Oregon.
www.manbaby.com

DEVIN CRANE 12700

Mr. Crane spends most of his time storyboarding hilarity at DreamWorks Feature Animation for the likes of **Shrek 2**, but he still saves energy to draw up panels for, say, a Run DMC video or to develop his own projects around Tinseltown.

DAVE CROSLAND 13600

Los Angeles slummin' Mr. Crosland is so avantcore, it hurts. You can enjoy all 8-bits worth of the art he makes on his wonderfully juicy website.
www.hiredmeat.com

GERALD DE JESUS 12800

Mr. De Jesus currently works out of Los Angeles and is influenced by the garden gnomes in his apartment complex to do unlawful things such as not recycling. He is a compulsive liar, and he really hates painting.
www.jdjartist.com

BOB DOB 01800

Born in Hermosa Beach, California, Mr. Dob cultivated a taste for adolescent unrest early on, playing in a punk band. Transmutation from music to art was a natural progression, providing a visual format to dramatize the beat of a disenfranchised youth culture.
www.bobdob.com

SANDRA EQUIHUA 12600

Señorita Equihua was born in Tijuana, Mexico—land of the maracas and burritos. She has many great influences but none as great as children's storybooks. Be warned: her drawings are so cute, they're contagious. The end.
www.fulanita.com

DAN FLERES 05400

Mr. Fleres is a passionate artist and musician from the California Bay Area with an uncanny penchant for drawing, painting, and creating (with thread and stuffing) a little creature he's dubbed the "Brobot"—like robots but cooler. www.danielfleres.com

JOSE EMROCA FLORES 04200

Between conceiving and storyboarding stuff for videogame megafranchises like **Medal of Honor** and **Lord of the Rings** for Electronic Arts in Los Angeles, Mr. Flores surfs (compulsively), races his lowrider (unlikely), and stares at disproportional people (secretly). www.emroca.com

BLAINE FONTANA 11800

Born and raised in the Puget Sound area of Washington, Mr. Fontana has developed a unique style, fusing illustration, fine art, and design—urban surrealism—inspired by world myth and Native American and African folklore and juxtaposed with urban textures, characters, and Asian elements. www.totembookmedia.com

MICHELLE GARDUNO 14200

Growing up in Los Angeles and having other artistic family members meant Ms. Garduno was always at arms with her brother to create (anything), finally finding her knack for shadow boxes.

PETER GRONQUIST 10400

Mr. Gronquist is an Oakland-based painter and sculptor. Contrary to popular belief, the quality of his work is surpassed only by his gigantic, mind-blowing ego. www.petergronquist.com

JORGE R. GUTIERREZ 10200

Raised by masked Mexican wrestlers, Señor Gutierrez quickly learned his manly art skills under the blessing of the Holy Virgin of Tequila. With that most sacred of dexterity, he creates animated bliss at Nickelodeon, Disney, Sony, and Warner Bros. www.super-macho.com

THOMAS HAN 02200

A walking, talking contradiction and a hopeless believer, Taiwan-born Mr. Han was somehow accepted in this weird, evolving art world, dedicating his life to painting pills, absurdly cute creatures that boogie, flying cigarettes, and addicted crab'bots. www.tomorama.com

AARON HORKEY 03200

Mr. Horkey is in a burlap sack. On his side, clawing at the base of the ditch with his bare hands. Twenty-seven years, rural Midwest forever. www.burlesquedesign.com

FOI JIMENEZ JURADO 02000

Ms. Jurado is a graphic artist from Tijuana, Mexico. She draws and paints every day with her daughter, Luna. She has been collaborating with musicians, artists, and graphic designers in the Tijuana cultural scene since 1992. www.foijimenezjurado.com

DAVID KNOTT 10700

Ten years ago, animation saved Mr. Knott from moving back to Michigan to work at Glamour Shots. He has since storyboarded for **Recess**, **Kim Possible**, and **Maggie** and is directing **The Emperor's New School** at Disney.

JOSHUA KRAUSE 08000

Mr. Krause makes art, drives around aimlessly in San Diego, California, and believes his best foot is starting to step forward. He also considers Ms. Pac-Man to be the first woman he ever loved... and the first woman who ever truly slipped away.
www.krauseart.com

ROMAN LANEY 03400

Mr. Laney is a tireless slave to the world of animation. When he's not plying his trade for Disney, Nickelodeon, and Warner Bros. or conceiving new characters and worlds, he's an avid music collector and bike enthusiast.
www.romanlaney.com

DENNIS LARKINS 04700

Working by day as a mild-mannered designer of cultural ephemera, Mr. Larkins spends his nights and weekends fighting for Truth, Justice, and Degenerate Art.
www.startlingart.com

JOE LEDBETTER 01600

Los Angeles's own Mr. Ledbetter likes to paint cute creatures that make destructive and disturbing adult behavior seem all so innocent. Alcoholism, breakups, samurai-sword decapitations—you know, suburban life served raw 'n' cuddly.
www.joeledbetter.com

JIM MAHFOOD 03600

Mr. Mahfood is a Los Angeles–based artist who makes comic books, designs T-shirts, paints live at various hip-hop and DJ events around the country, and enjoys tacos. A lot. Probably too much. But he keeps in shape. Kinda.
www.40ozcomics.com

MIKE MATEI 08600

When Mr. Matei isn't playing **Yars' Revenge**, he's busy exposing more pop culture than you can shake an annoying Encyclopedia Britannica kid at, drawing comics and narrowly recognized TV stars from decades past.
www.mikematei.com

TIM MCCORMICK 10500

A Southern California native, Mr. McCormick's inspiration comes from a love for and a need to make art. His work is about all aspects of life, from the most profound to the most trivial: everything is relative; everything is important.
www.timmccormickart.co

BRENDAN MONROE 11200

Mr. Monroe likes strange creatures and foreign lands. His imagery often includes things derivative of nature that are then twisted and brought to life like some kind of science experiment gone bad.
www.brendanmonroe.com

TONY MORA 12200

After his sudden demise as a runway supermodel, Mr. Mora resorted to a less-hectic lifestyle of animating cartoons for Disney and Warner Bros., drawing stuff (like his doggies, Persephone and Maximo), and kickin' it NoHo style with his lovely wife, Amanda.

www.sobaditsgood.blogspot.com

ERIK OTTO 02600

With a degree in illustration and animation, experience ranging from set production to graphic design, and a love for all materials, Mr. Otto enjoys constructing art from discarded paint and found objects. In his spare time, he creates cool shirts for cool people.
www.erikotto.com

DANIEL PEACOCK 13000

A native of Southern California, Mr. Peacock has been painting and drawing mostly rodents and various rogue pheasants in his work, which often encompasses Eastern theology and small chocolate donuts.
www.danielpeacock.com

JOHN PHAM 03500

Mr. Pham's favorite games were always the ones in which he could beat up on his younger brother and cousins, like **Street Fighter**. His favorite jobs: meticulously screen printing comic books and infiltrating the Los Angeles gallery scene.
www.epoxypress.com

ISAAC PIERRO 13900

Mr. Pierro is a Los Angeles local artist who dreams big and paints even bigger, currently infiltrating the Hollywood gallery scene in preparation for his world domination plot.
www.isaacpierro.com

PLASTICGOD 11600

Plasticgod's clean, minimalist forms; simple shapes; and saccharine colors reduce an ever-expanding pantheon of pop-culture icons to their most basic visual identifiers, entering them into his vision of immortality.
www.plasticgod.com

STEVE PURCELL 12900

When he's not whipping up obscure, self-indulgent paintings, Mr. Purcell spends his adult adolescence creating comic books, videogames, and TV animation (like **Sam & Max**) and is currently developing stories for feature films at Pixar in San Francisco.
www.spudvision.com

CARLOS RAMOS 06000

After graduating from Cal Arts in 1997, Mr. Ramos got saddled into animation at Cartoon Network, Disney, and currently Nickelodeon, where he created **The X's**. He enjoys video-games, movies, music, and everything else that is responsible for corrupting today's youth.
www.monkeypuzzles.com

CHRIS RECCARDI 03000

Mr. Reccardi is a director, animator, painter, storyboard artist, designer, and musician who has worked on **The Ren & Stimpy Show**, **Samurai Jack**, and **Super Robot Monkey Team Hyper Force Go!** He lives in Los Angeles with his hyper-talented wife, Lynne Naylor.

KATIE RICE 03800

Ms. Rice watches too many cartoons and plays too many videogames but still finds time to draw cute, big-headed girls for your visceral enjoyment, all from her home in Los Angeles.
www.katierice.homestead.com

JIM RUGG 05200

East Coaster Mr. Rugg is the co-creator of **Street Angel.** He works as a graphic designer during the day and draws comic books at night. His wife—and cat—hate comics, wrestling, and videogames.
www.streetangelcomics.com

SCOTT SAW 05600

Born in San Diego, Mr. Saw creates vibrant, energetic paintings where dreams and current surroundings cross-pollinate with childhood memories and subconscious interpretations of the afterlife.
www.scottsaw.com

ZEN SEKIZAWA 07600

Since graduating from the Art Center College of Design in Pasadena, California, photography-obsessed Ms. Sekizawa has appeared in **Graphis** and worked on numerous national and international advertising, music, and editorial projects.
www.zensekizawa.com

JASON SHO GREEN 07700

After studying autonomous robotics, embedded digital systems, and math at the University of Washington, Mr. Sho Green has started to get back into art for the first time since grade school (so much for college degrees).
www.jasonshogreen.com

GREG "CRAOLA" SIMKINS 09400

Mr. Simkins spent most of his youth hiding from the monsters under his bed in a hollowed-out tree in his Southern California backyard. While out there, he was befriended by a group of rabbits trained in the ninja arts, building confidence and skills aplenty. Turns out the monsters weren't that scary—they just wanted to pose for him. So now he paints his new friends and enjoys tall glasses of Ovaltine.
www.iamscared.com

BRIAN SINGER 05300

Despite hours of dedication and plenty of sore thumbs, San Francisco—based Mr. Singer couldn't beat any videogames without resorting to cheats. He compensates for this by launching absurdly large art experiments, like The 1000 Journals Project.
www.1000journals.com

CLAY SISK 14600

Mr. Sisk is an artist-illustrator working from a secret underground location somewhere in Texas. Word is that he's a nice guy—though some say he is a robot (but it's only a rumor, damn it).
www.siskart.com

SKET ONE 14300

Between hanging out with his family and designing figures for today's hottest toy companies, how Sket One finds the time to demean the corporate icons we all love to hate is anyone's guess.
www.sket-one.com

MICHAEL SLACK 04600

San Jose–based Mr. Slack is an artist, character designer, and occasional animator. His illustrations have appeared in numerous publications, including **Time**, **Computer Gaming World**, and the **New York Times**, and he's currently toiling away on several children's' books.
www.slackart.com

EMILY SMITH 04400

Ms. Smith is a photographer living in Michigan, just kind of winging it and harboring an unreasonable love for baseball.
www.shutterbabe.org

NATHAN STAPLEY 10800

Mr. Stapley helped to create the critically acclaimed videogame **Psychonauts** with some of his talented friends and is a founding contributor to the comic book **Hickee**, published by Alternative Comics. He also loves the sun but not in a worshipful kind of way.
www.nathanstapley.com

JJ STRATFORD 09200

Ms. Stratford's work is an exploration of the world and the hidden messages in everyday life, often displayed in a series of photographs that spring from her life's adventures and obsessions in and around Los Angeles.
www.jjstratford.com

DETH P. SUN 11300

Mr. Sun went to school at the California College of Arts and Crafts, where he received a BFA in painting and drawing. He recently relocated to Los Angeles and is thinking of moving again.

GABE SWARR 06800

Born to yokels in small-town Pennsylvania, Mr. Swarr parlayed his love for Miyamoto, Clampett, and Tezuka into a crusade to make cartoons as cartoony as damn possible via studios like Cartoon Network, Nickelodeon, and Spümcø.
www.bigpantsmouse.com

SEAN SZELES 06300

A San Diego native, Mr. Szeles doesn't surf—he draws. He went to CalArts and loves cartoons. He also loves cats, but not hats—unless they're top hats.
seanszeles.blogspot.com

MILES THOMPSON 13400

Mr. Thompson likes painting, drawing, music(ing), reading, traveling, cooking, hiking, movie(ing), nature(ing), oste-ology, and Rempel squeak toys. He also might live in Los Angeles. Maybe.
www.kooch-e-koo.com

TIM TOMKINSON 08800

Mr. Tomkinson works out of his home in Brooklyn, New York. Aside from gallery showings, he creates regular illustrations for a range of editorial, advertising, and institutional clients. When not working, he likes to hang out with his wife and his two overweight cats.
www.timtomkinson.com

NIKKI VAN PELT 04500

Ms. Van Pelt's multidisciplinary practice includes drawing, painting, and sculpting. Through paintings of models, cultural icons, and her friends, she explores issues of both public and private identity from her digs in Los Angeles.
www.nikkivanpelt.com

AMANDA VISELL 02800

Ms. Visell is one-half of a two-headed monster. Her likes are gelato, story songs, and dogs that make people sounds. Her dislikes are hot feet, sleep deprivation, and people that make dog sounds. She also paints stuff in Los Angeles.
www.thegirlsproductions.com

CHIP WASS 12000

An award-winning professional illustrator, Mr. Wass lives—and works—in New York. He's terribly fond of chimpanzees, physical fitness, and the occasional well-made cocktail. If he could come to a decision about it, he'd have a lot of tattoos. Clients include Nike, Disney, Nickelodeon, Cartoon Network, and the **New York Times**, among many others.
www.worldofwassco.com

DAVE WASSON 10600

A bastard child of the Midwest, Mr. Wasson ventured to Los Angeles to contaminate the animation industry with his ideas, creating **Time Squad** for Cartoon Network and directing various commercials and series here and there.

TRENT WATANABE 09300

Mr. Watanabe spends most of his time laying out local publications in Santa Barbara, California. With the rest of his time he paints, breaks up toys to make other toys, and leaves town whenever he can.
www.trentwatanabe.net

ASHLEY WOOD 02500

Mr. Wood is the self-proclaimed king of ass and robots—and allegedly Australian. Also known for an unnatural like of cats. And, on occasion, he'll tend to one of his many comic-book franchises, such as World's Best Robots or Popbot.
www.ashleywood.com

YOSKAY YAMAMOTO 13800

Born in the Land of the Rising Sun, Mr. Yamamoto spent his youth idolizing Japanese graphic novels and playing endless hours of NES. Now he lives in San Francisco where he paints, experimenting with various art forms—from Ukiyo-e to Graffiti, Picasso to Twist—and lives as a starving, student artist.
www.yoskay.com

720° is a trademark of Midway Amusement Games, LLC. Asteroids is a registered trademark of Atari Interactive, Inc. Bubble Bobble is a registered trademark of Taito Corp. Centipede is a registered trademark of Atari Interactive, Inc. Civilization is a registered trademark of Atari Interactive, Inc. Contra is a registered trademark of Konami (America), Inc. Defender is a trademark of Midway Amusement Games, LLC. Dig Dug is a registered trademark of Namco Ltd. Donkey Kong is a registered trademark of Nintendo of America, Inc. Double Dragon is a registered trademark of Technos Japan Hanbai K.K. Duck Hunt is a registered trademark of Nintendo of America, Inc. Excitebike is a registered trademark of Nintendo of America, Inc. Frogger is a registered trademark of Konami Co., Ltd. Grand Theft Auto is a registered trademark of Take-Two Interactive Software, Inc. Joust is a trademark of Midway Amusement Games, Inc. Kid Icarus is a registered trademark of Nintendo of America, Inc. M.U.L.E. is a registered trademark of Electronic Arts, Inc. Mario Bros. is a registered trademark of Nintendo of America, Inc. Medal of Honor is a registered trademark of Dream Works Interactive, LLC. Mega Man is a registered trademark of Capcom Co., Ltd. Metal Gear is a registered trademark of Konami (America), Inc. Metroid is a registered trademark of Nintendo of America, Inc. Missile Command is a registered trademark of Atari Interactive, Inc. Ms. Pac-Man is a registered trademark of Namco, Ltd. Nintendo Entertainment System is a registered trademark of Nintendo of America, Inc. PlayStation is a registered trademark of Sony Computer Entertainment. Pong is a registered trademark of Atari Interactive, Inc. Rampage is a registered trademark of Midway Amusement Games, LLC. Sinistar is a trademark of Midway Amusement Games, LLC. Space Invaders is a registered trademark of Taito Corp. Street Fighter II is a registered trademark of Capcom Co., Ltd. Street Fighter is a registered trademark of Capcom Co., Ltd. Super Mario Bros. 2 is a registered trademark of Nintendo of America, Inc. Super Mario Bros. is a registered trademark of Nintendo of America, Inc. Tetris is a registered trademark of The Tetris Company, LLC. The Legend of Zelda is a registered trademark of Nintendo of America, Inc. Tron is a registered trademark of Cooper Industries, Inc. Yars' Revenge is a registered trademark of Atari Interactive, Inc. Zelda is a registered trademark of Nintendo of America, Inc.